ILLUSTRATED BY:
LAURA LIVI

DESIGNED BY:
LAURA LIVI & CORRADO SESSELEGO

COLOR IT WITH FLOWERS! © 2019 BLUE MONKEY STUDIO
(PUBLISHED THROUGH THE ZENITH BOOKS PUBLISHING LINE)

ALL ARTWORK © 2016-2019 BLUE MONKEY STUDIO

ANY OMMISSION OR INCORRECT INFORMATION SHOULD BE TRANSMITTED TO THE AUTHOR OR THE PUBLISHER SO IT CAN BE RECTIFIED IN FUTURE EDITION OF THIS BOOK.

NO PART OF THIS BOOK MAY BE USED OR REPRODUCED IN ANY MANNER WHATSOEVER WITHOUT WRITTEN PERMISSION EXCEPT IN THE CASE OF BRIEF QUOTATIONS EMBODIED IN CRITICAL ARTICLES AND REVIEWS.

COLOR IT WITH FLOWERS!

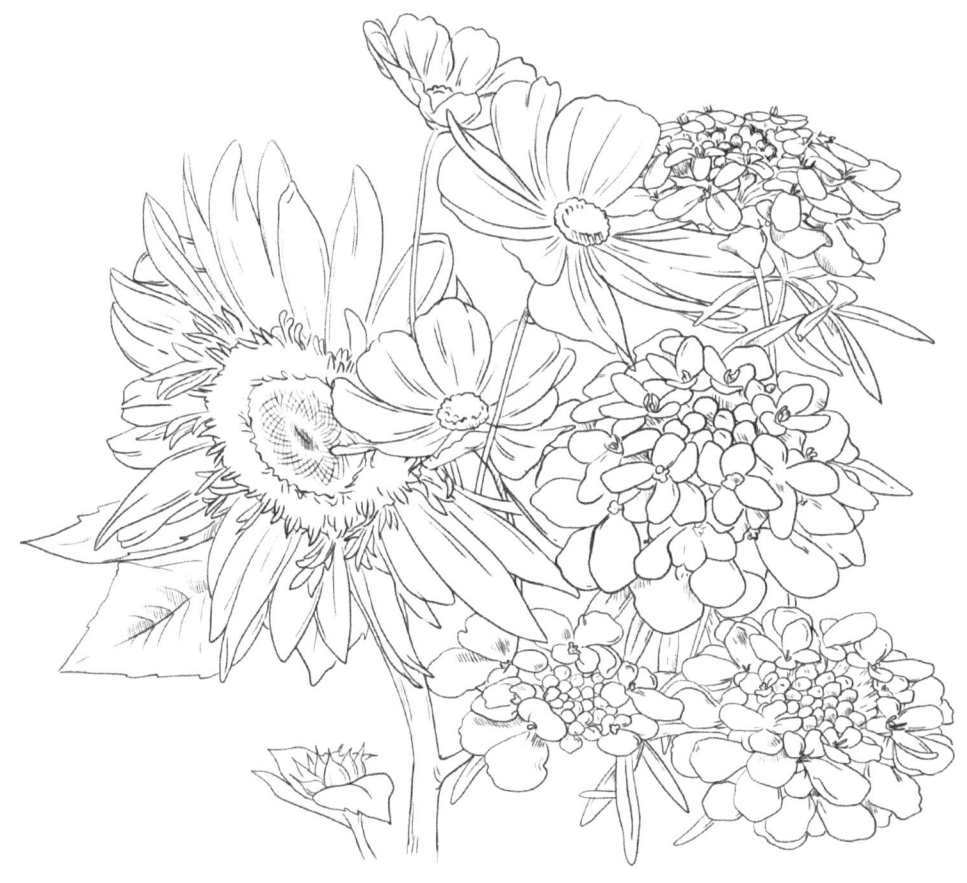

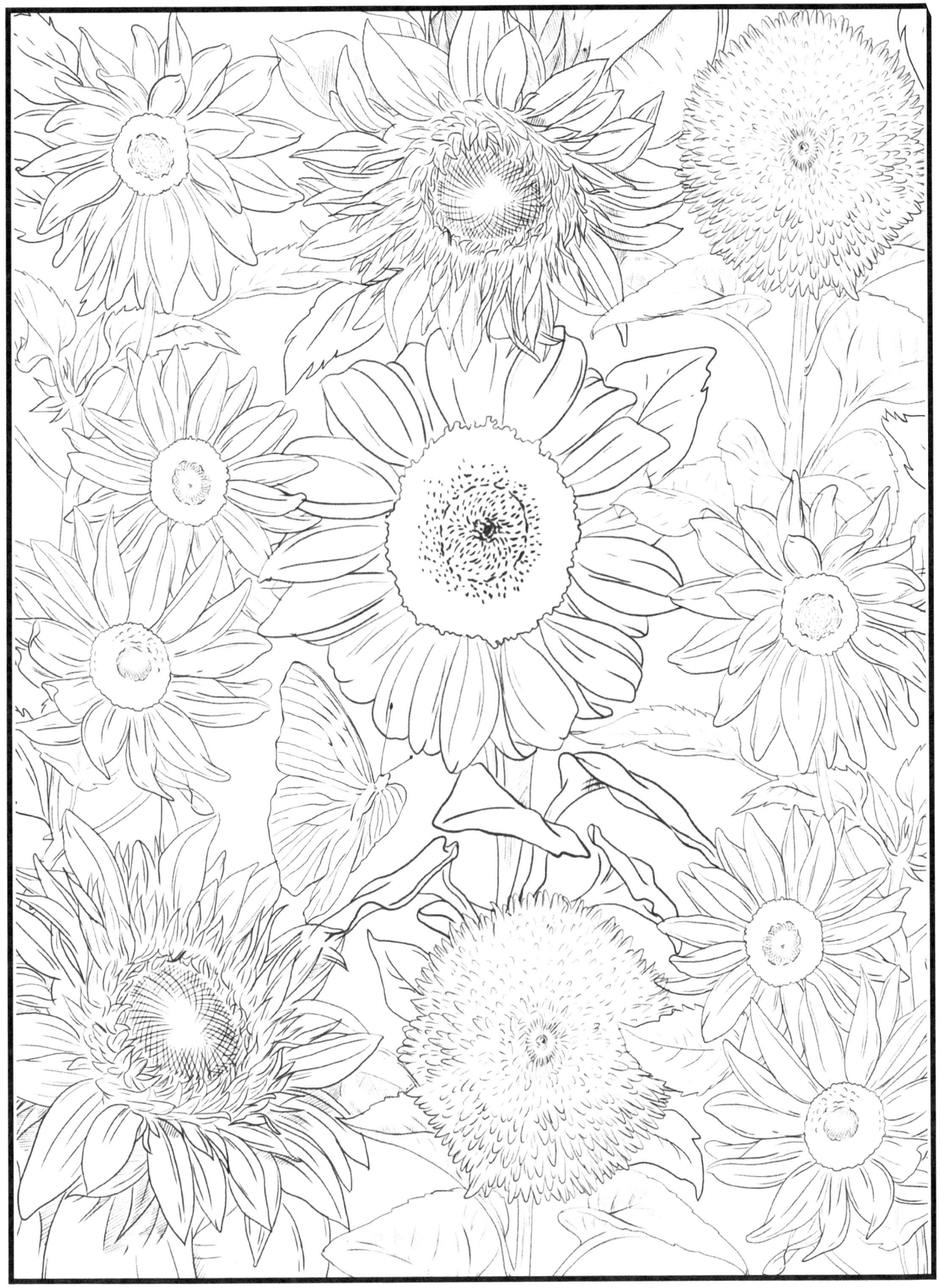

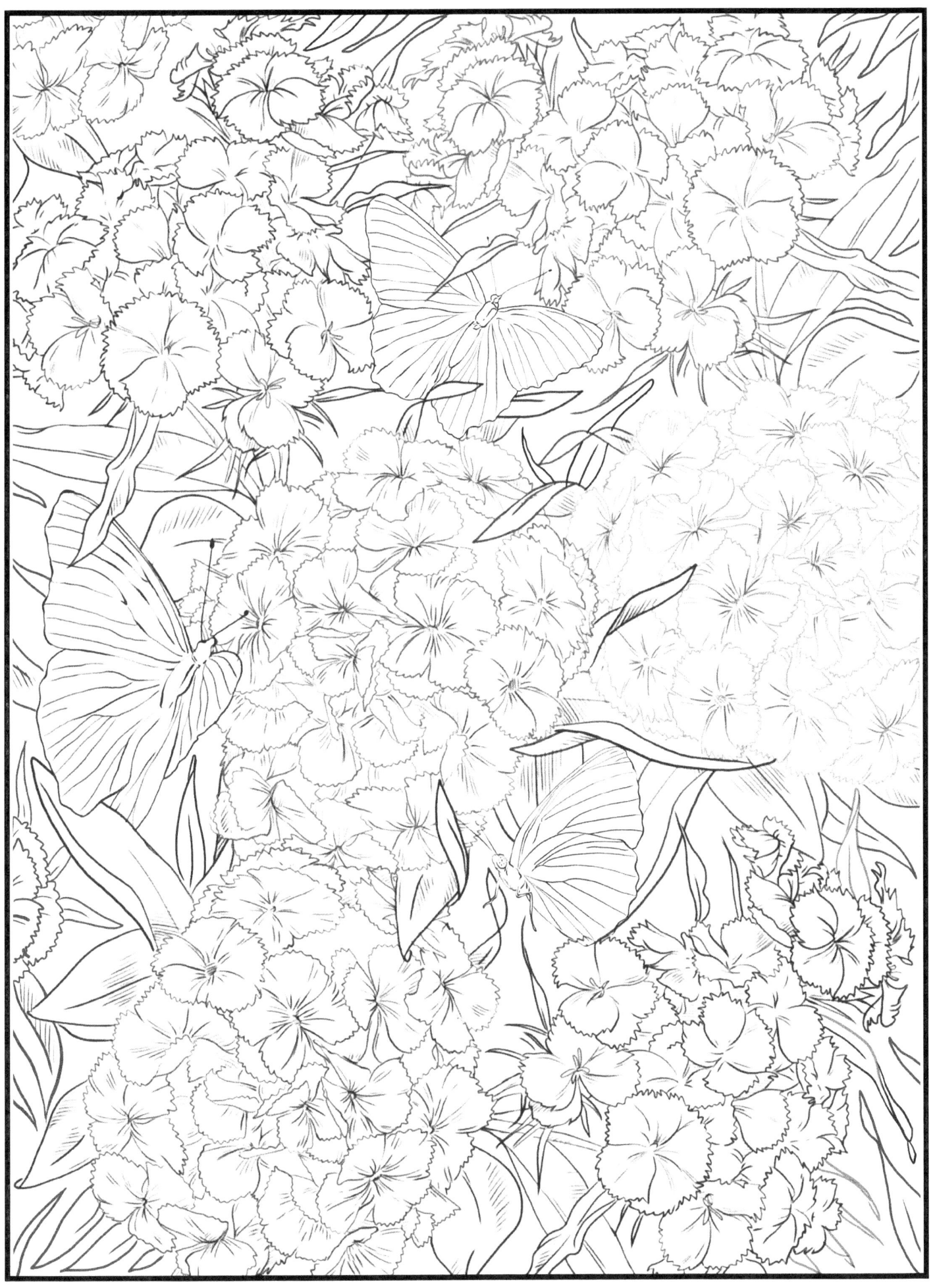

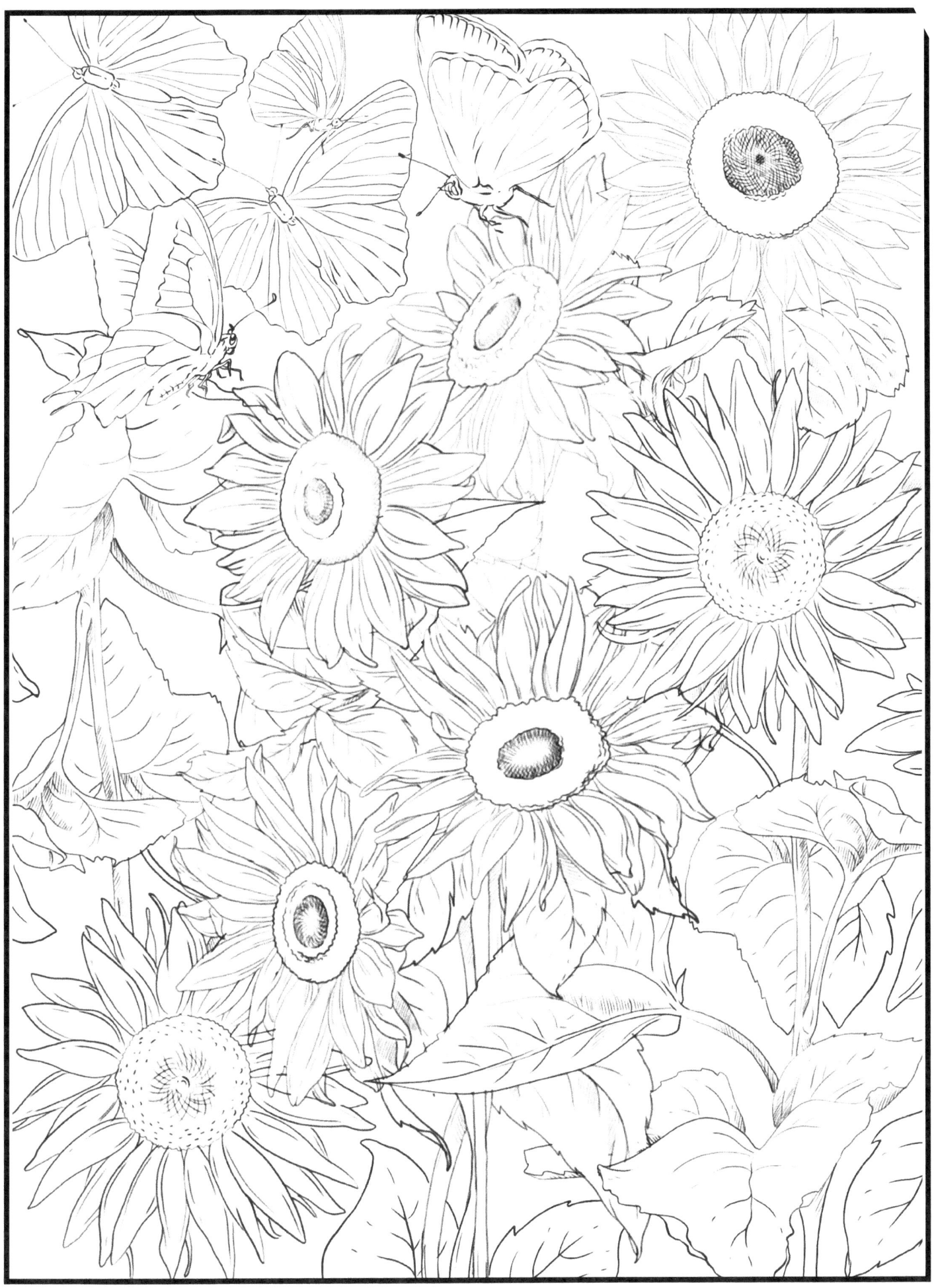

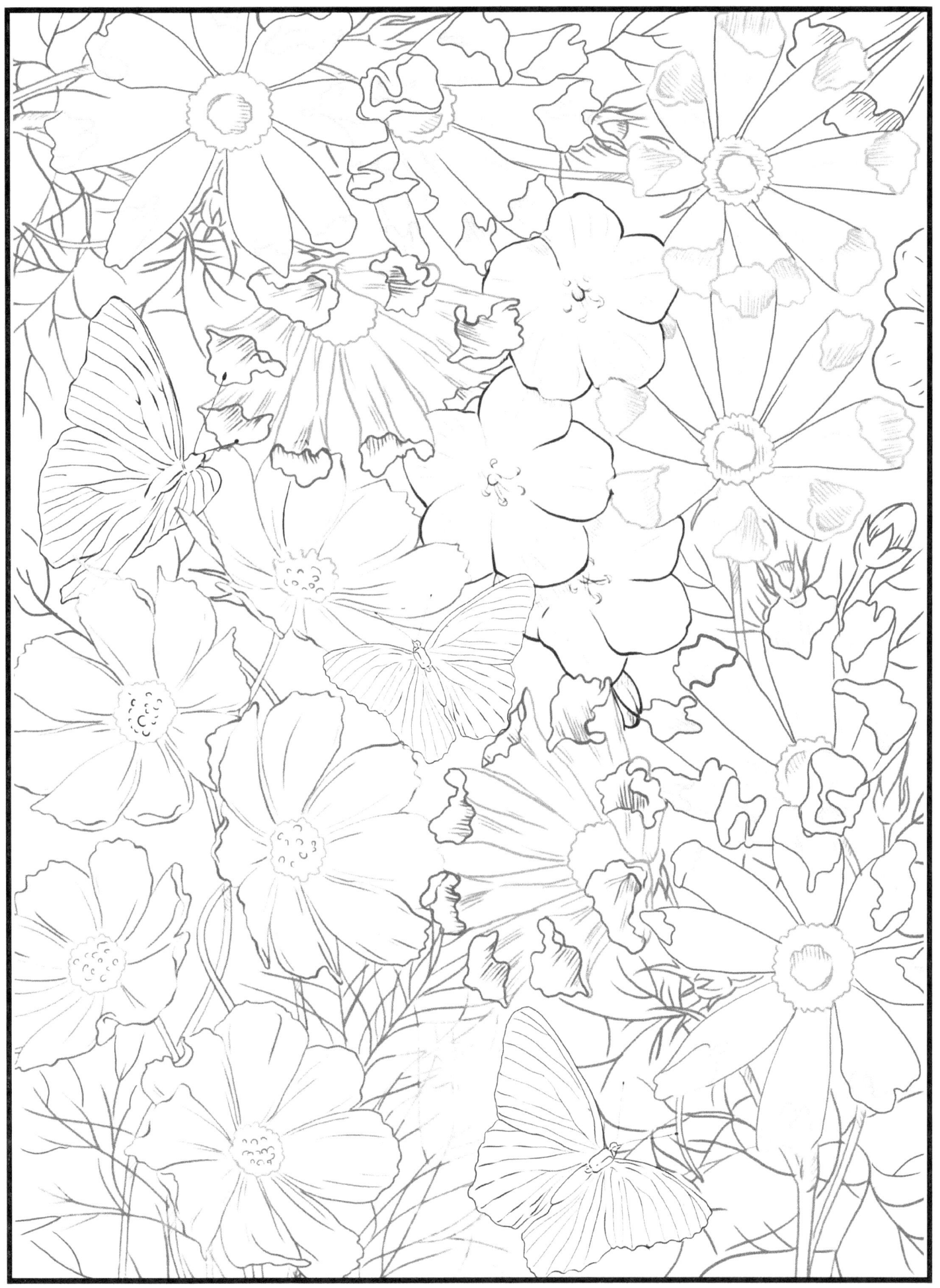

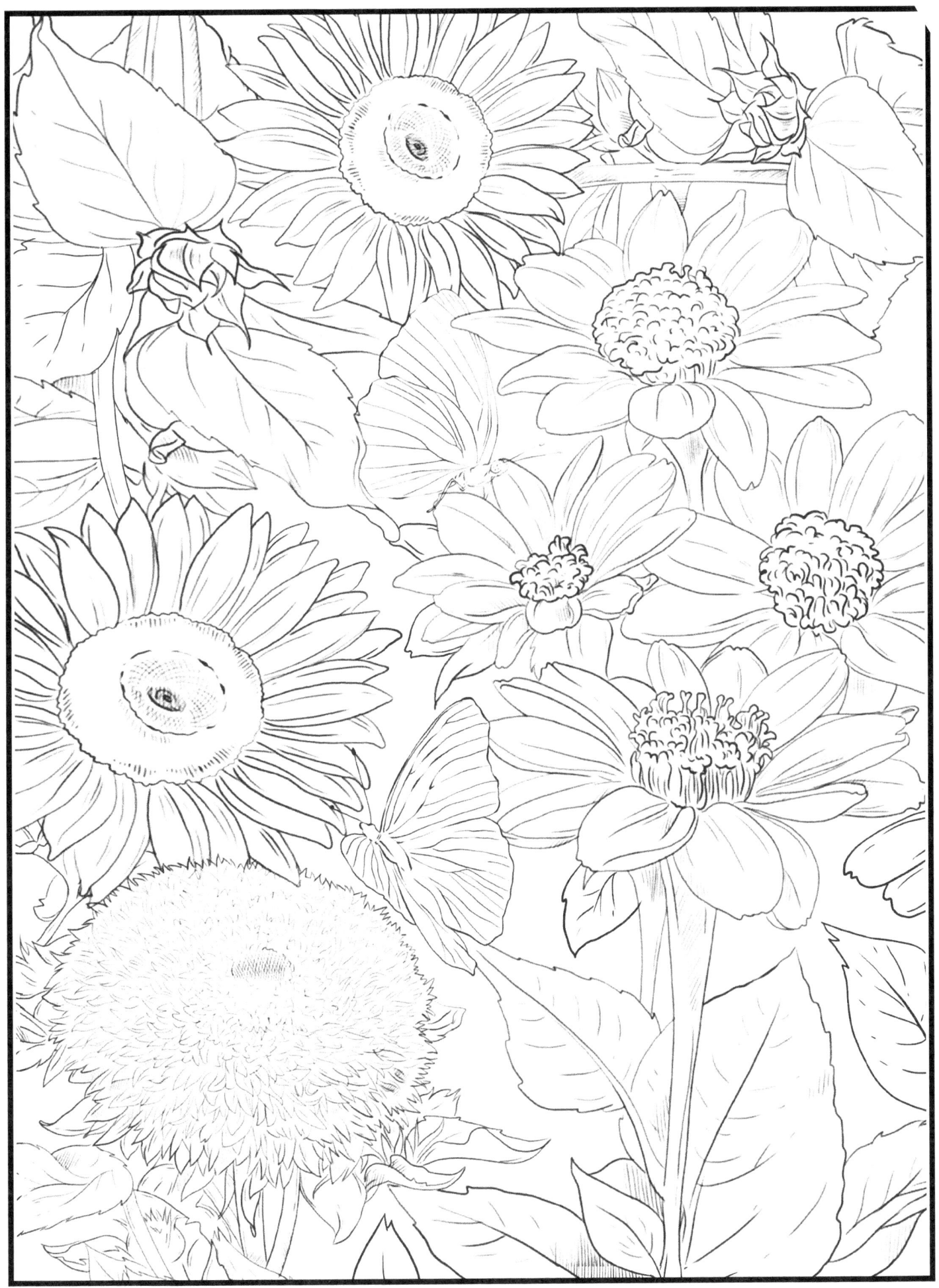

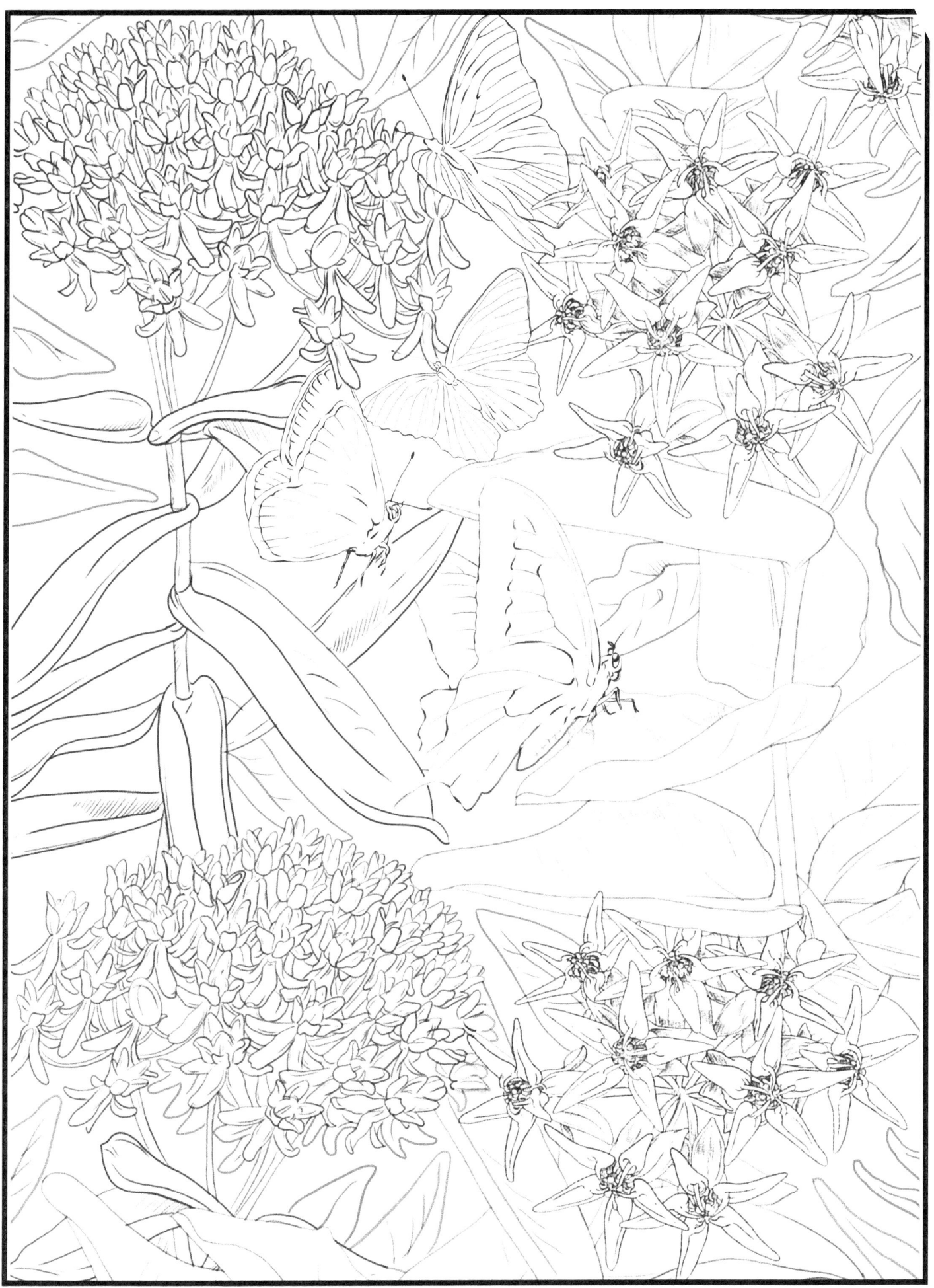

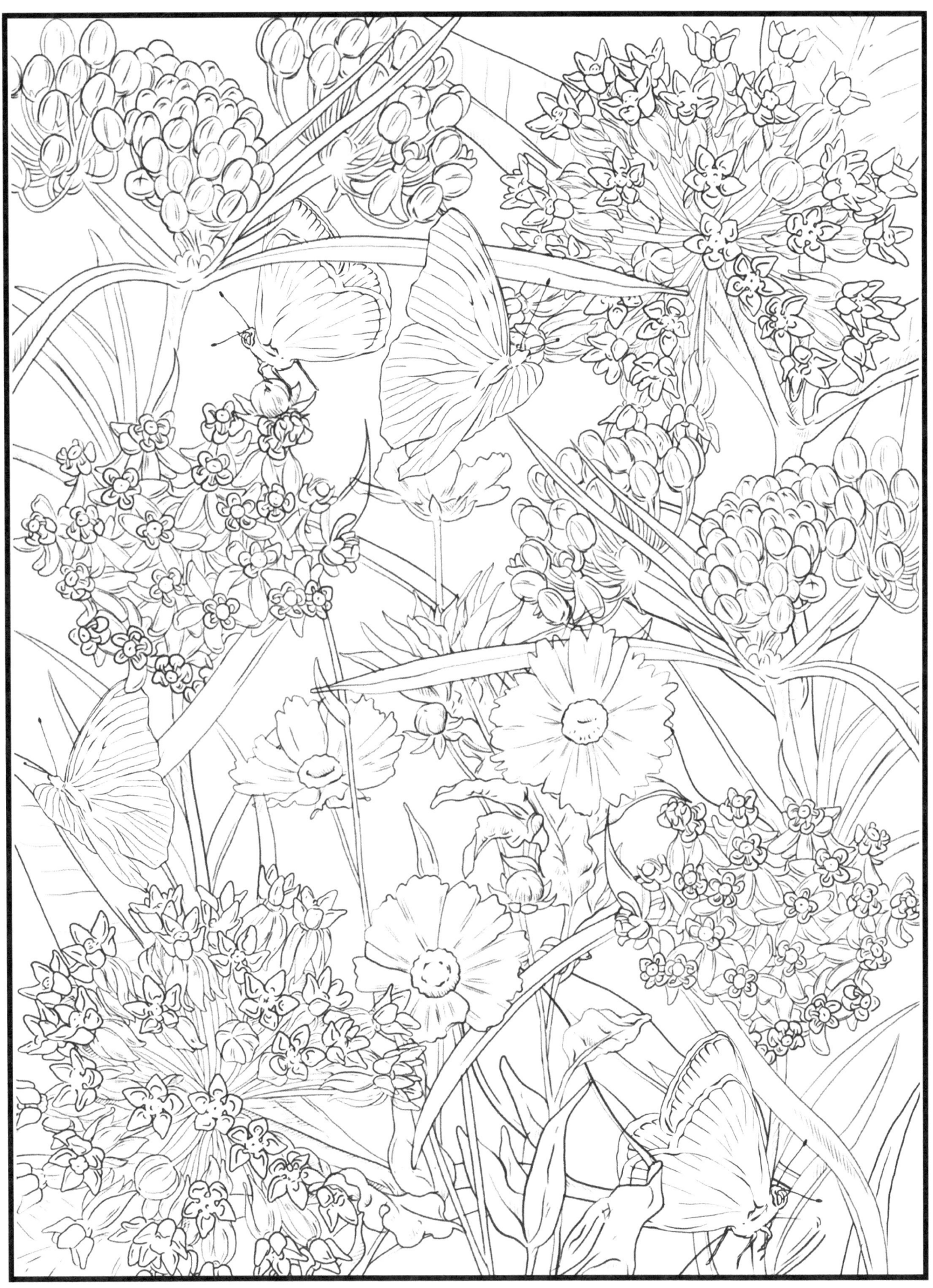

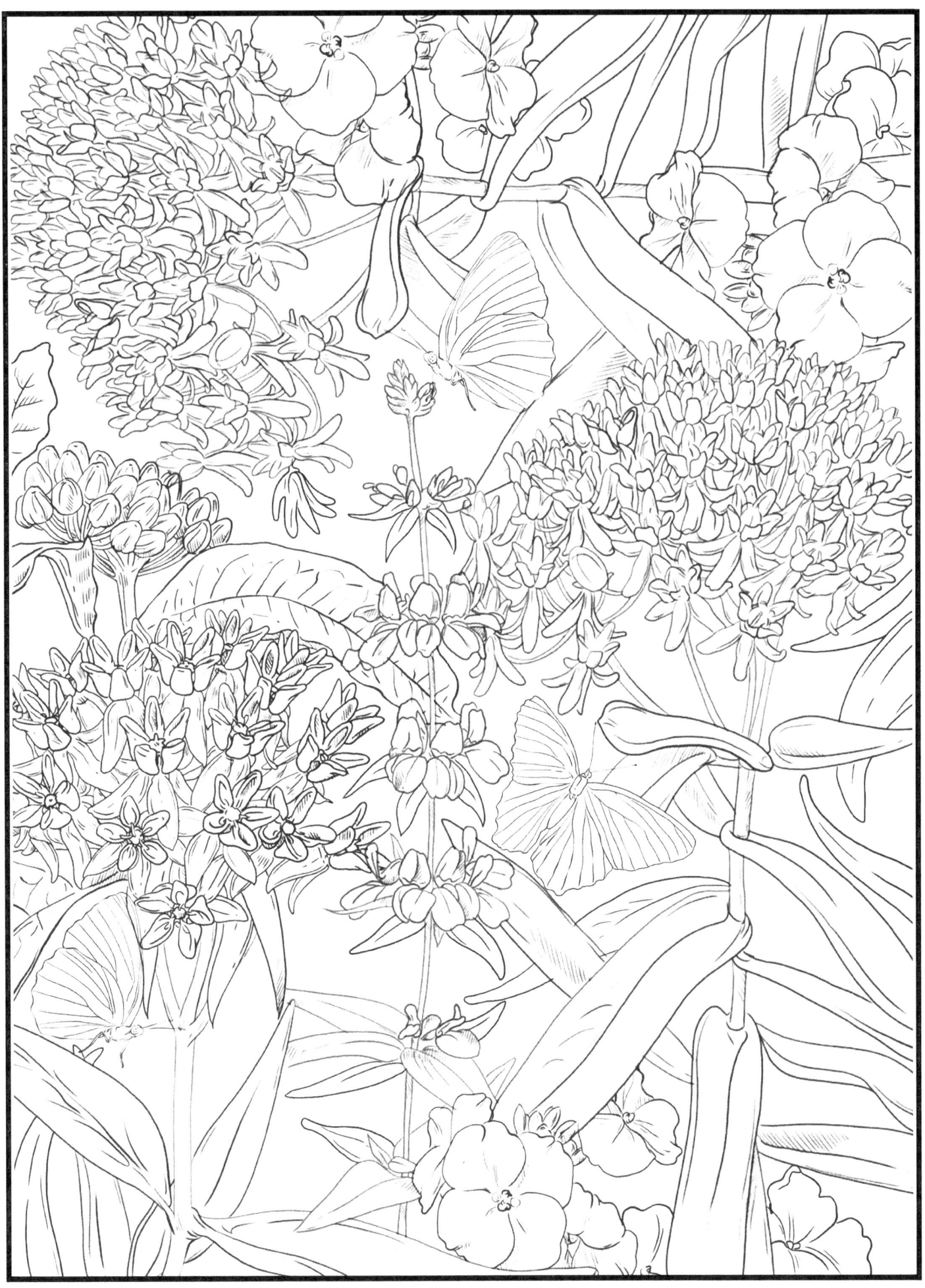

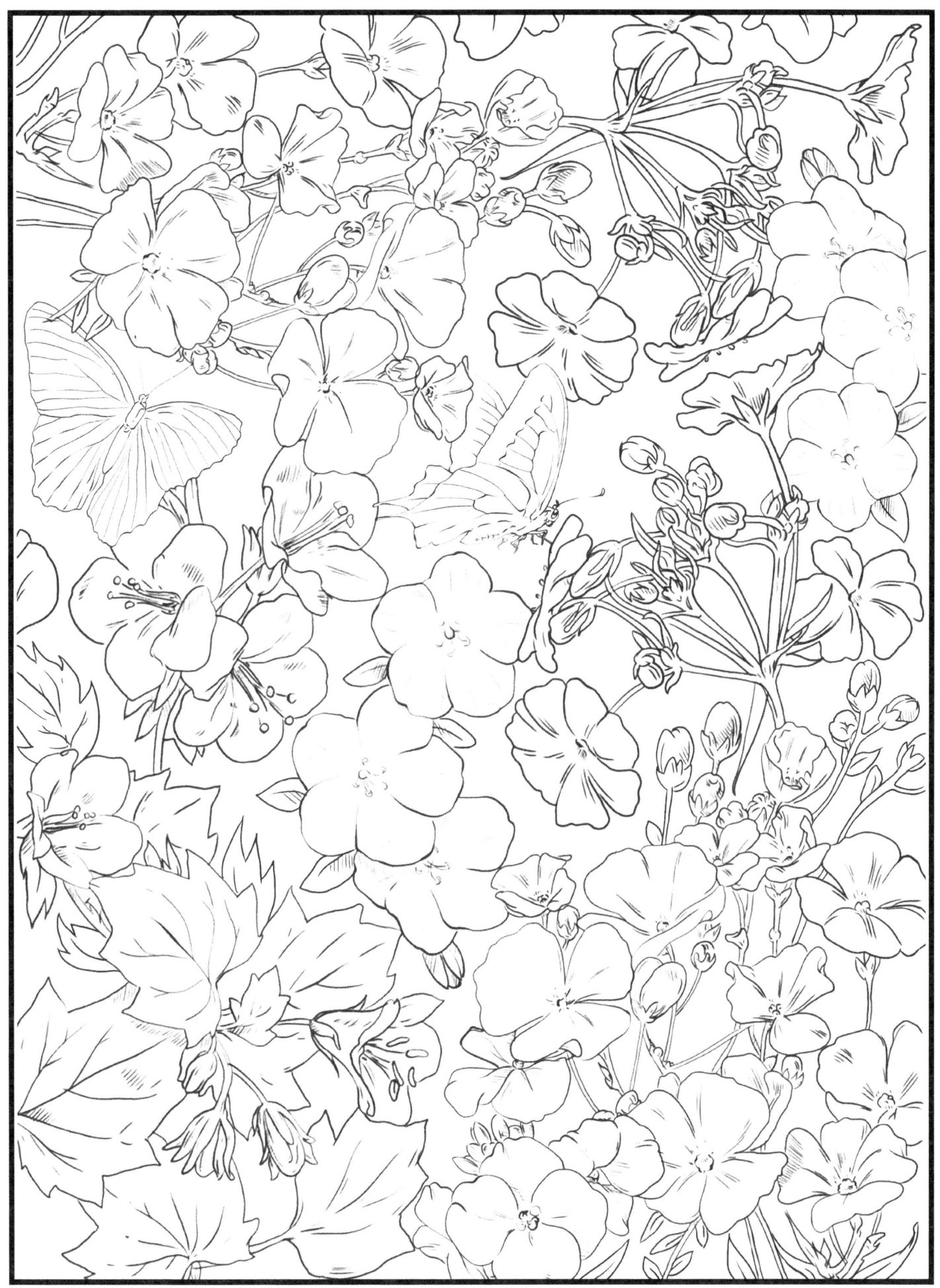

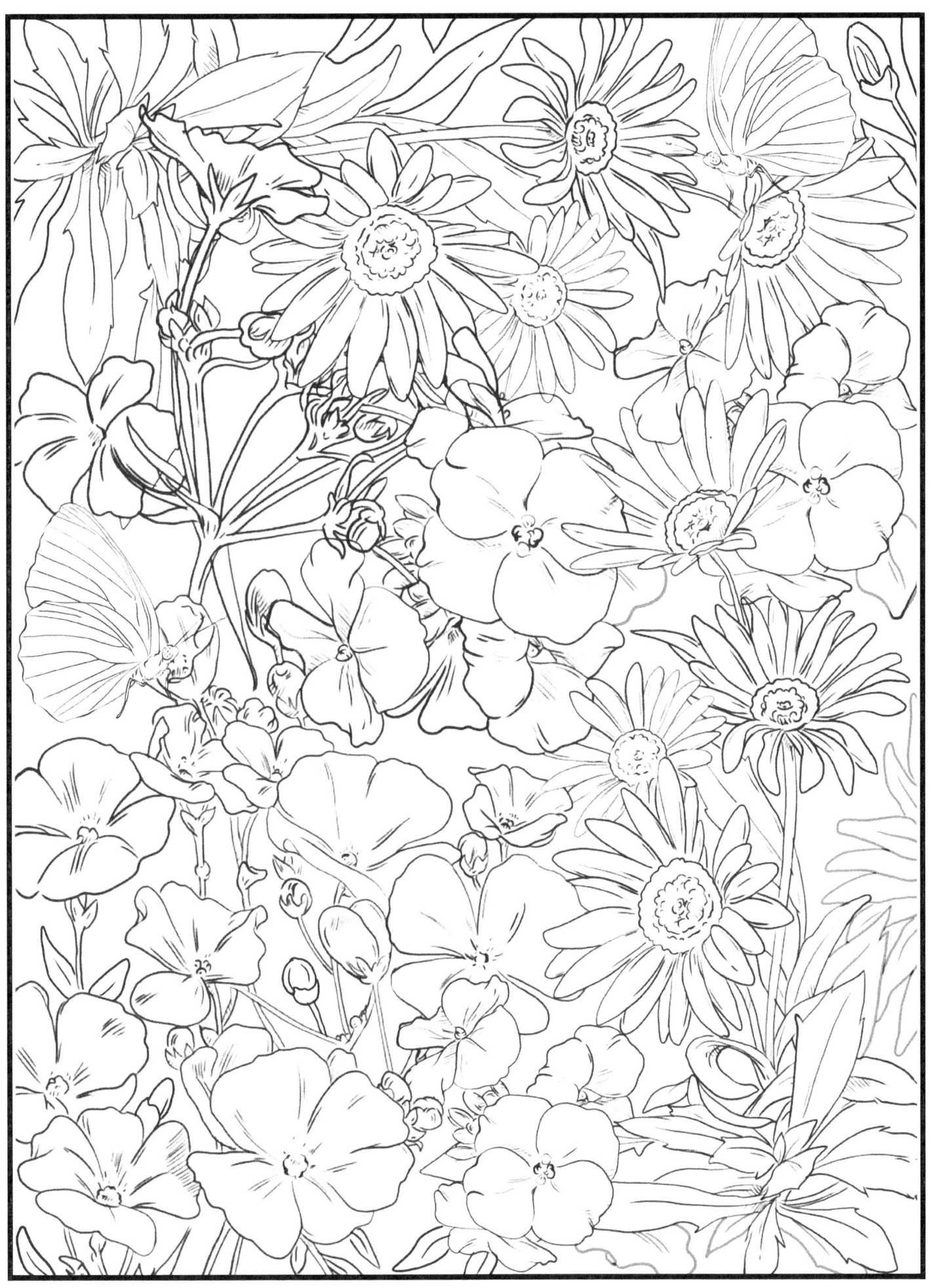

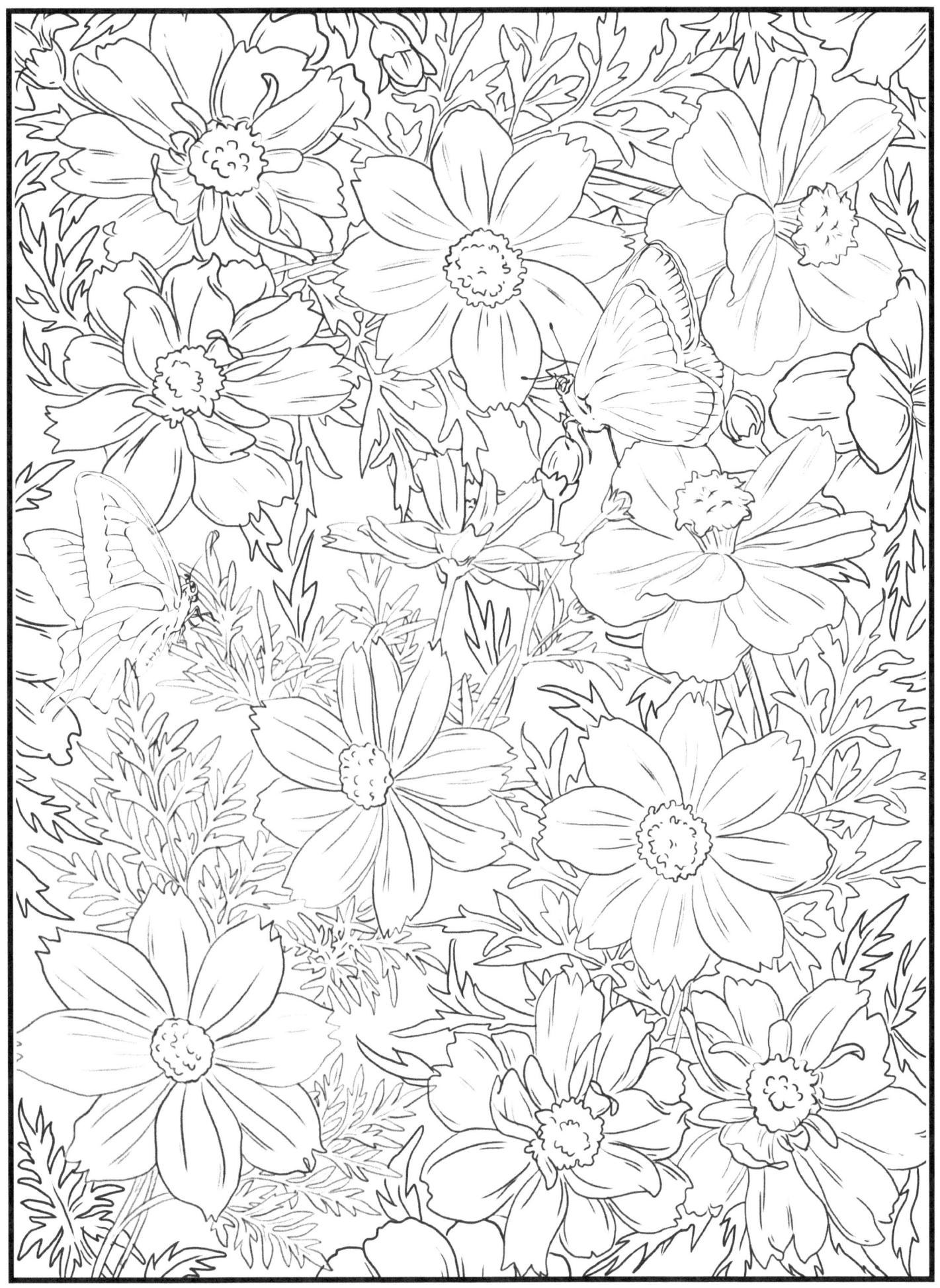

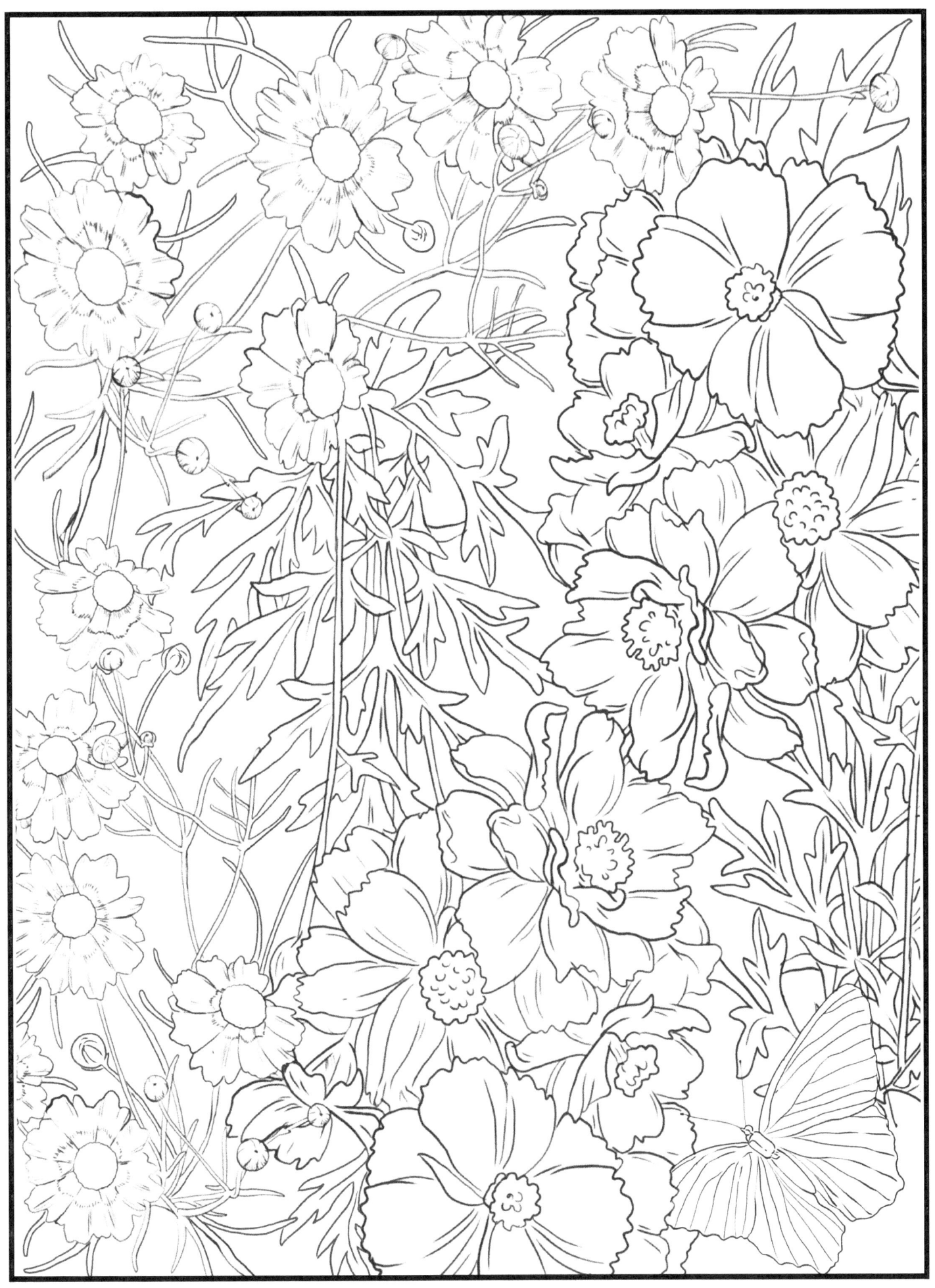

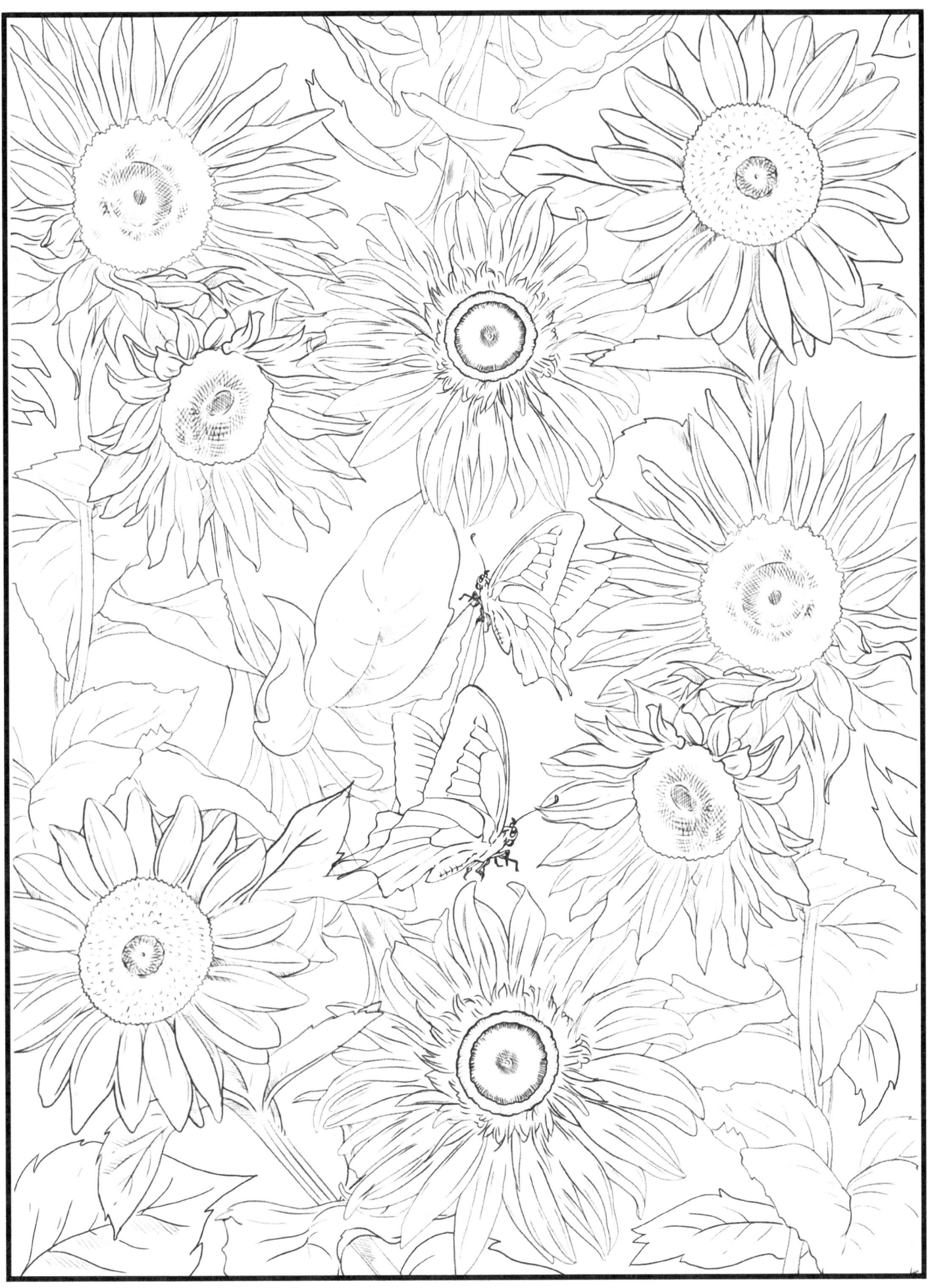

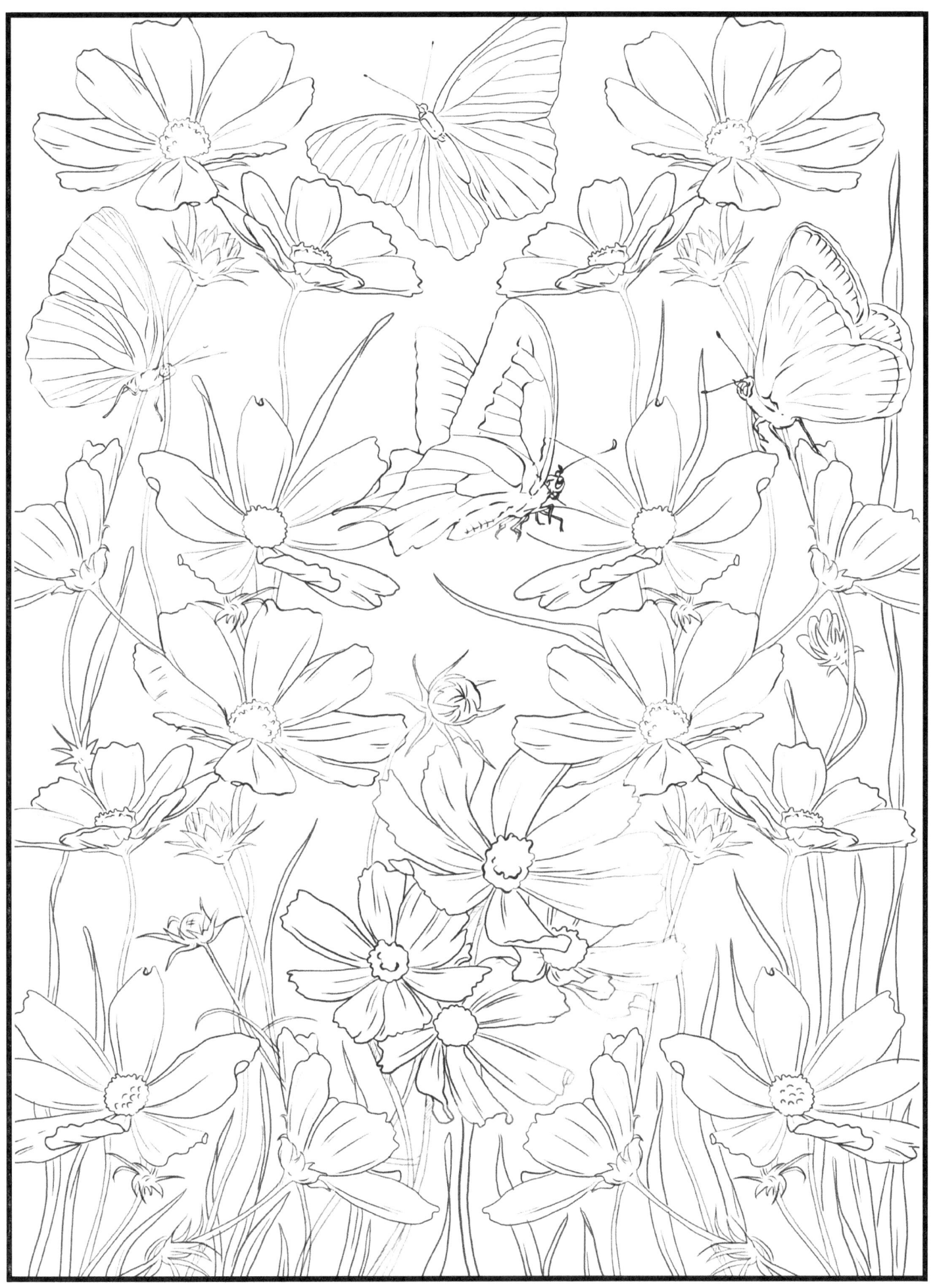

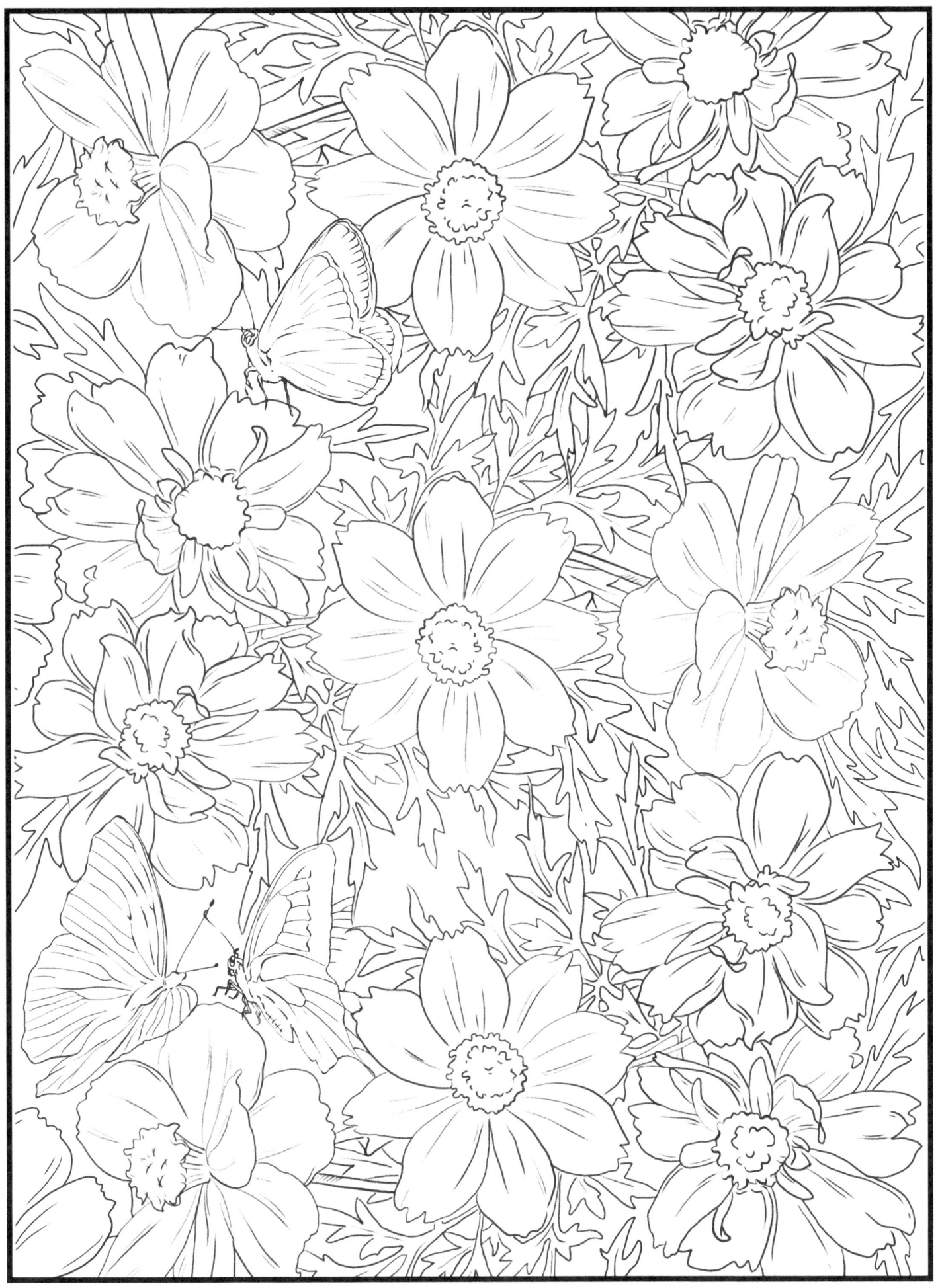

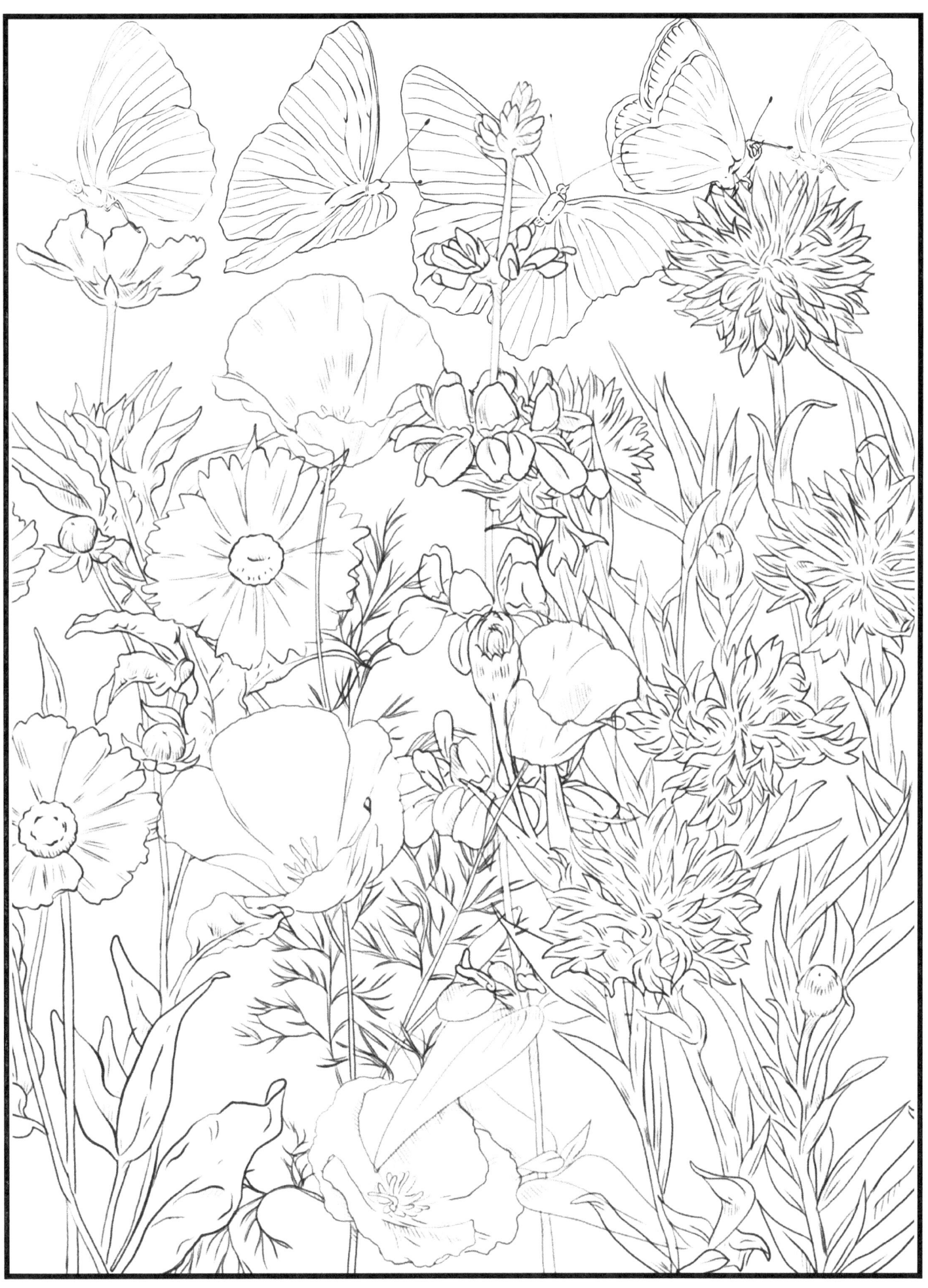

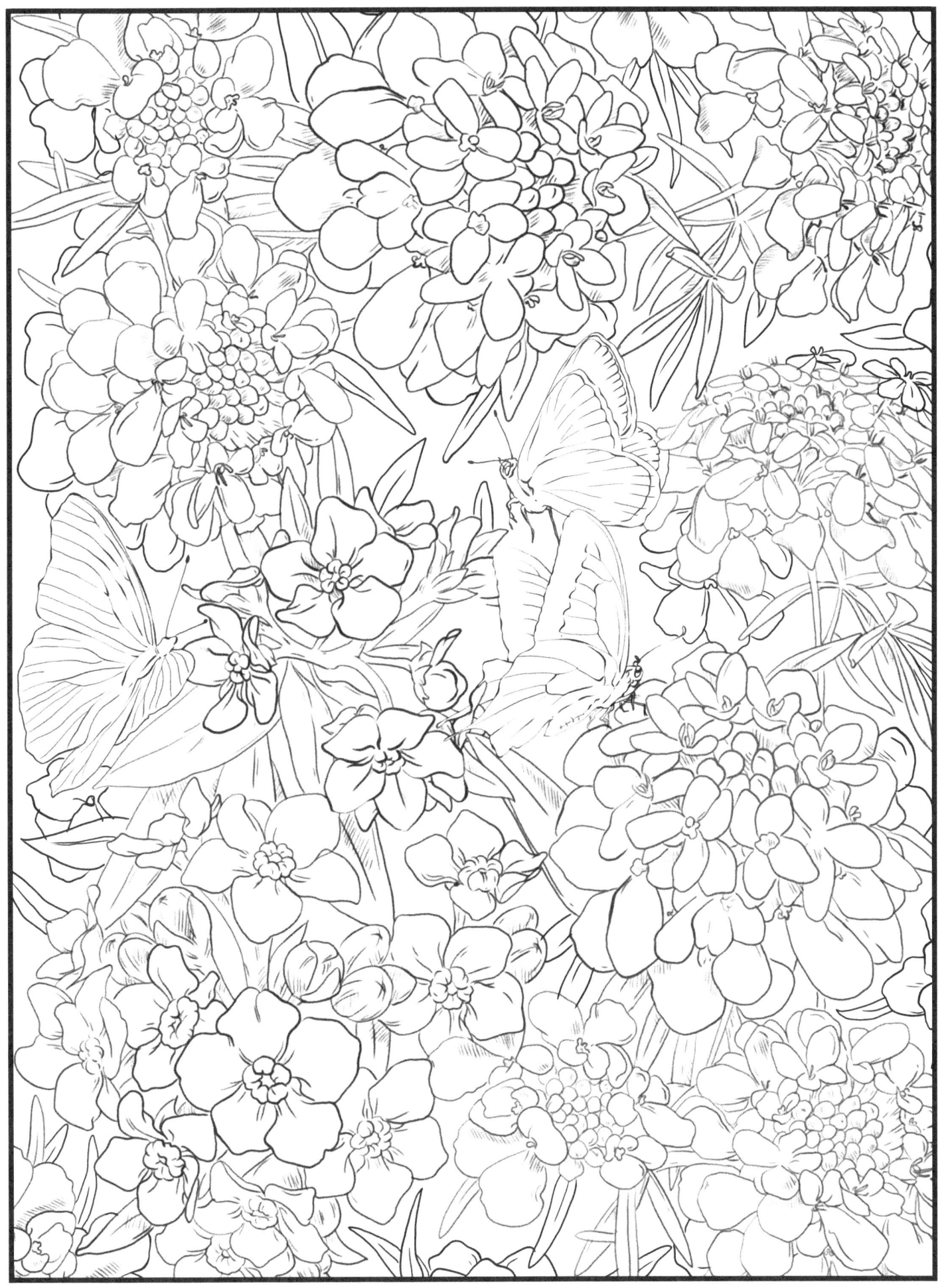

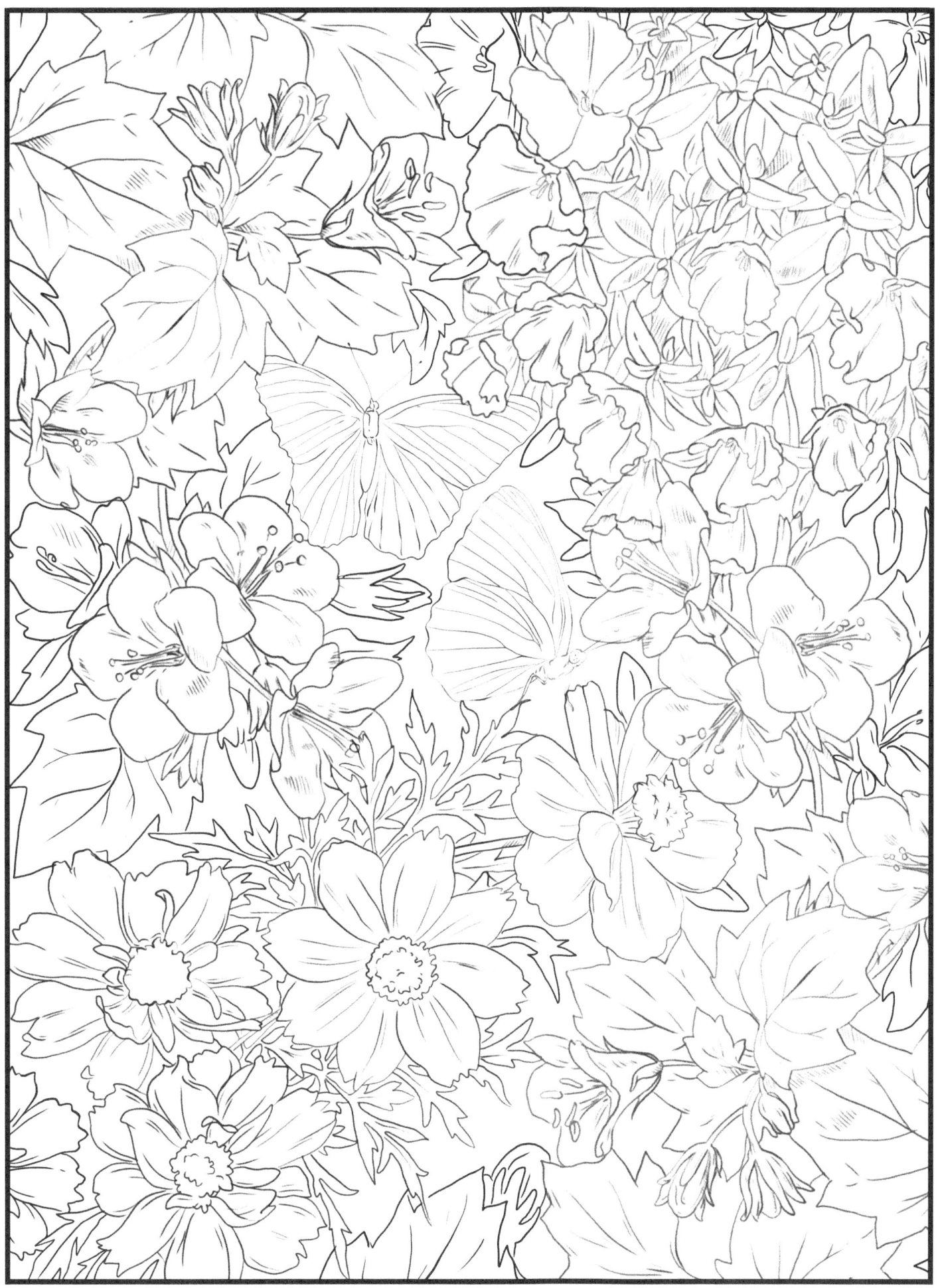

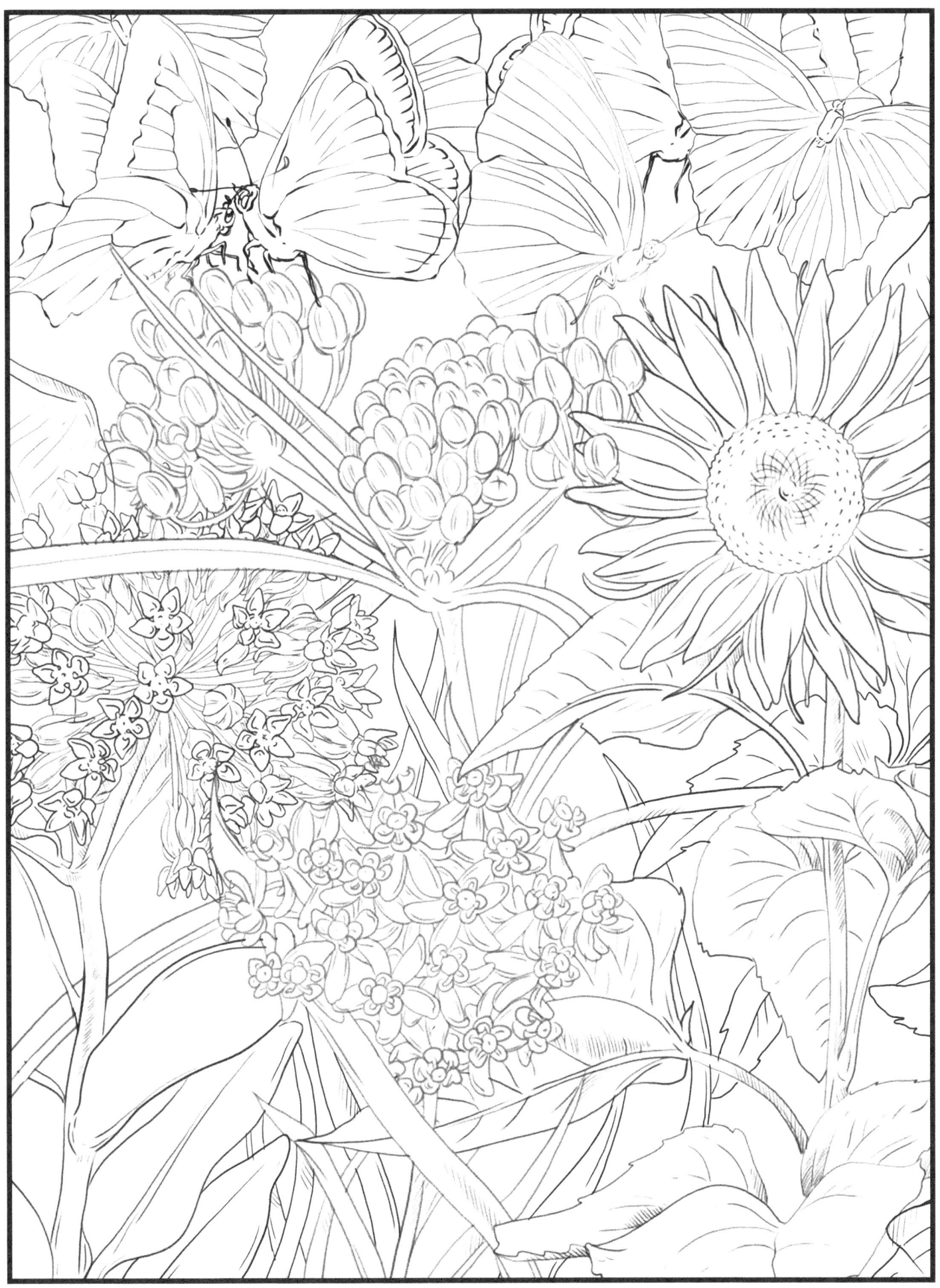

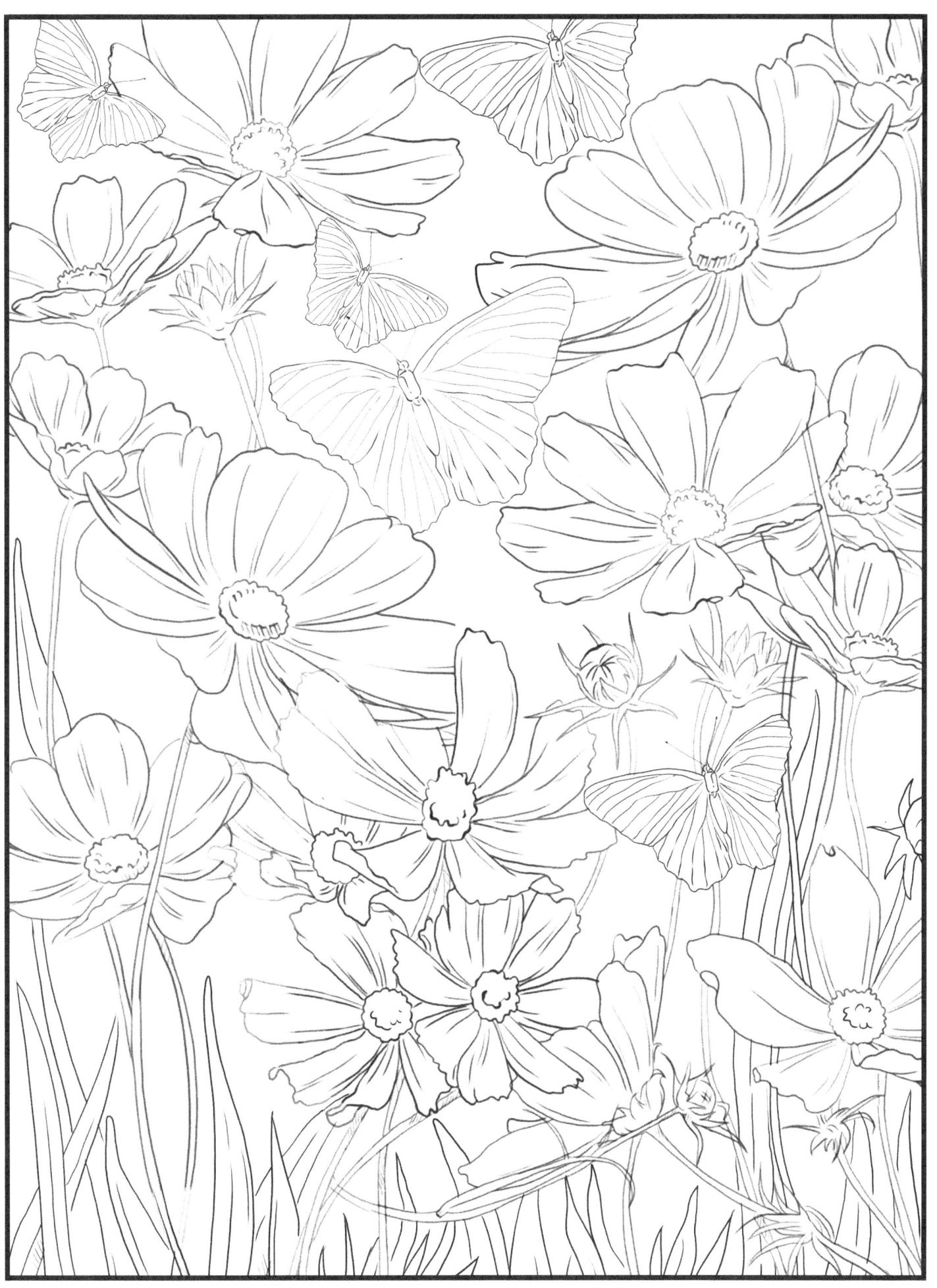

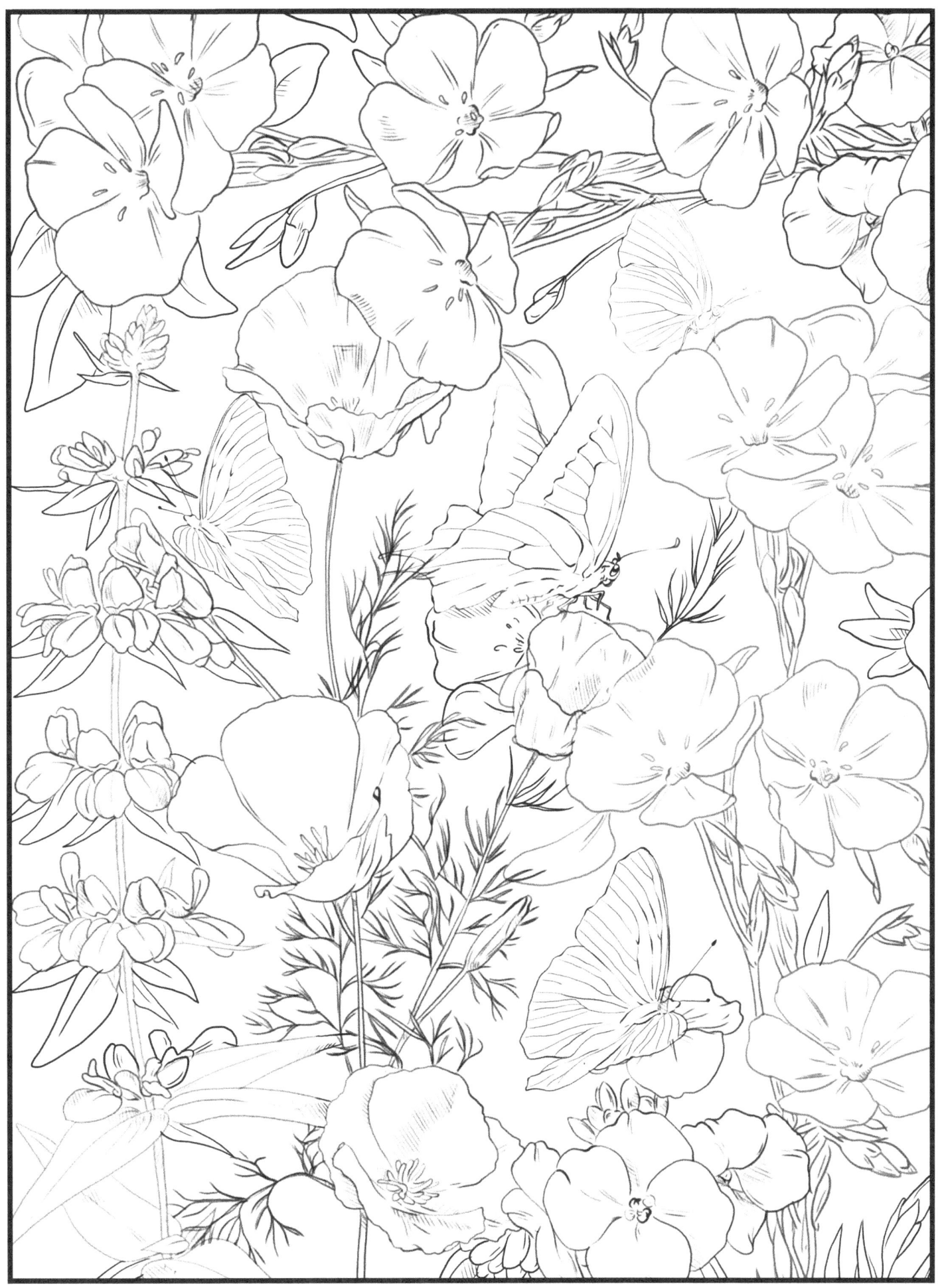

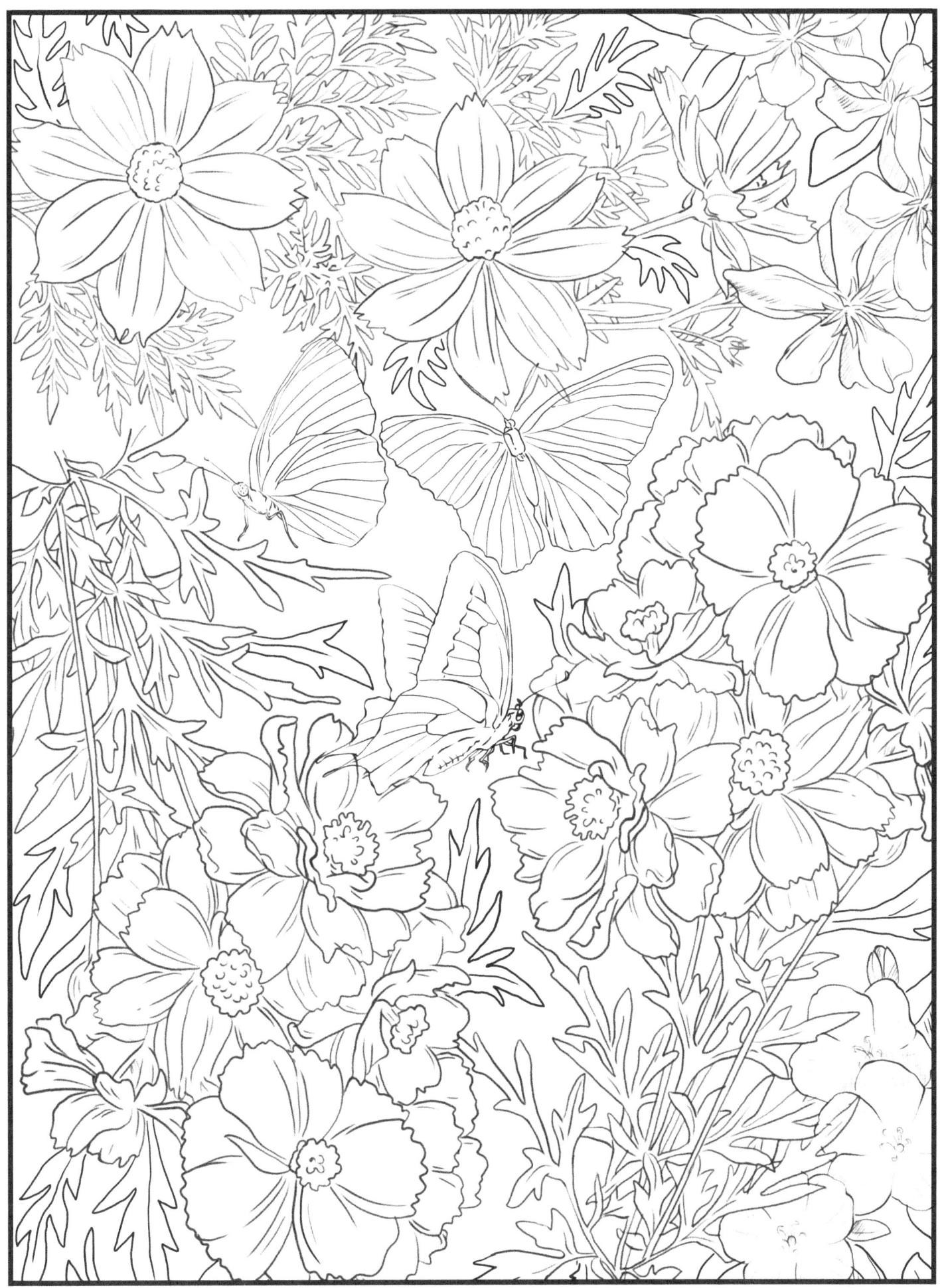

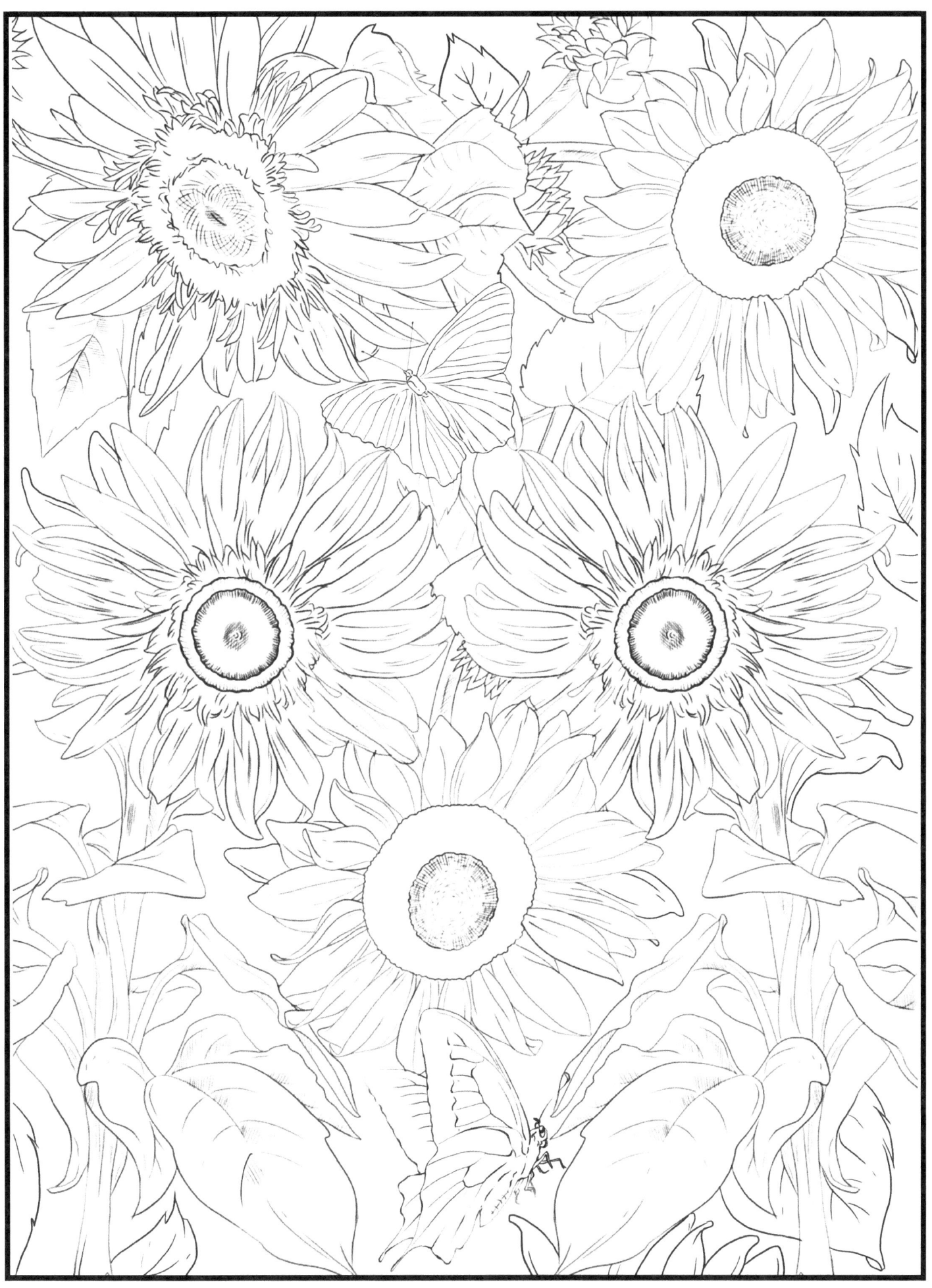

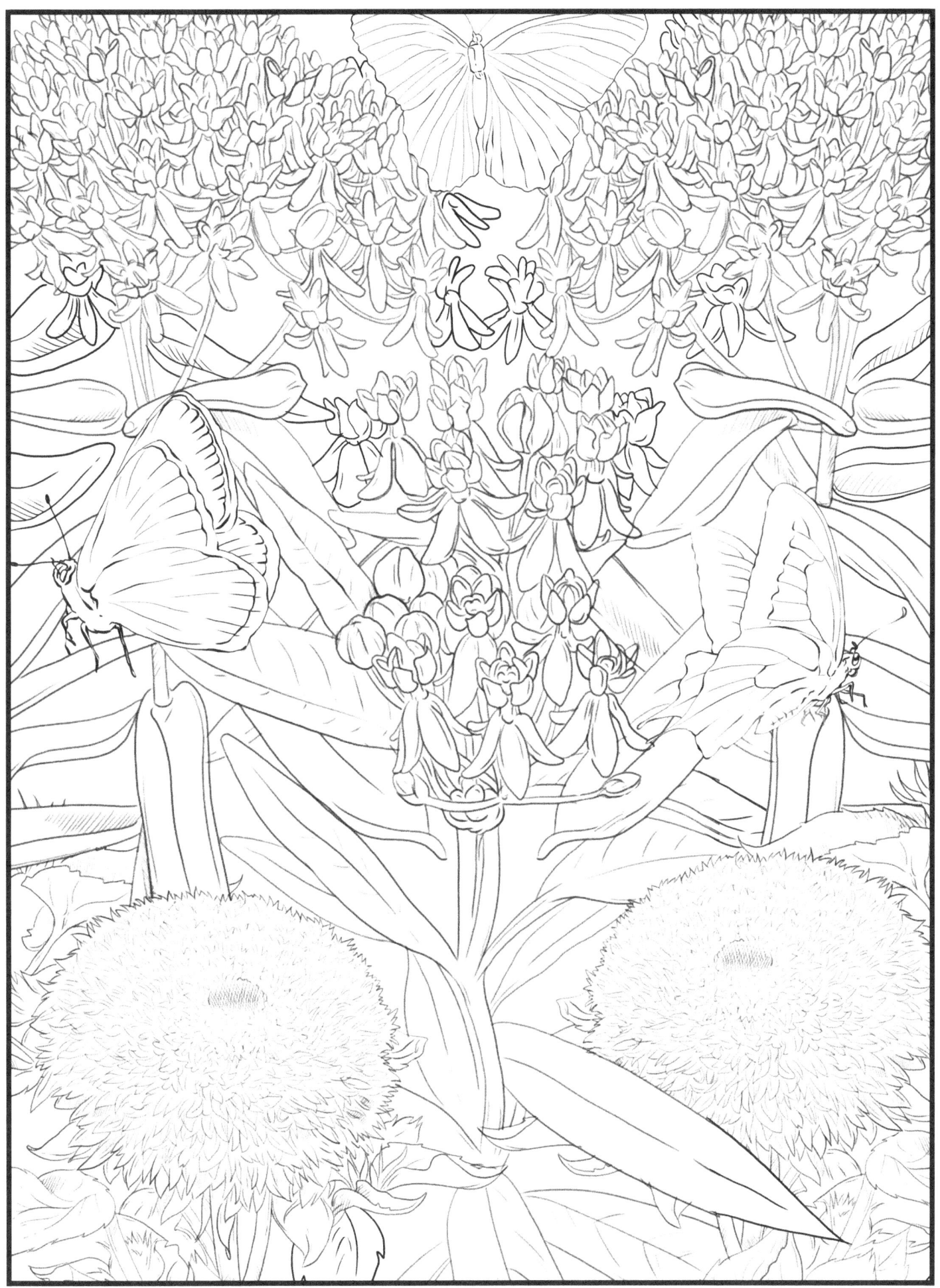

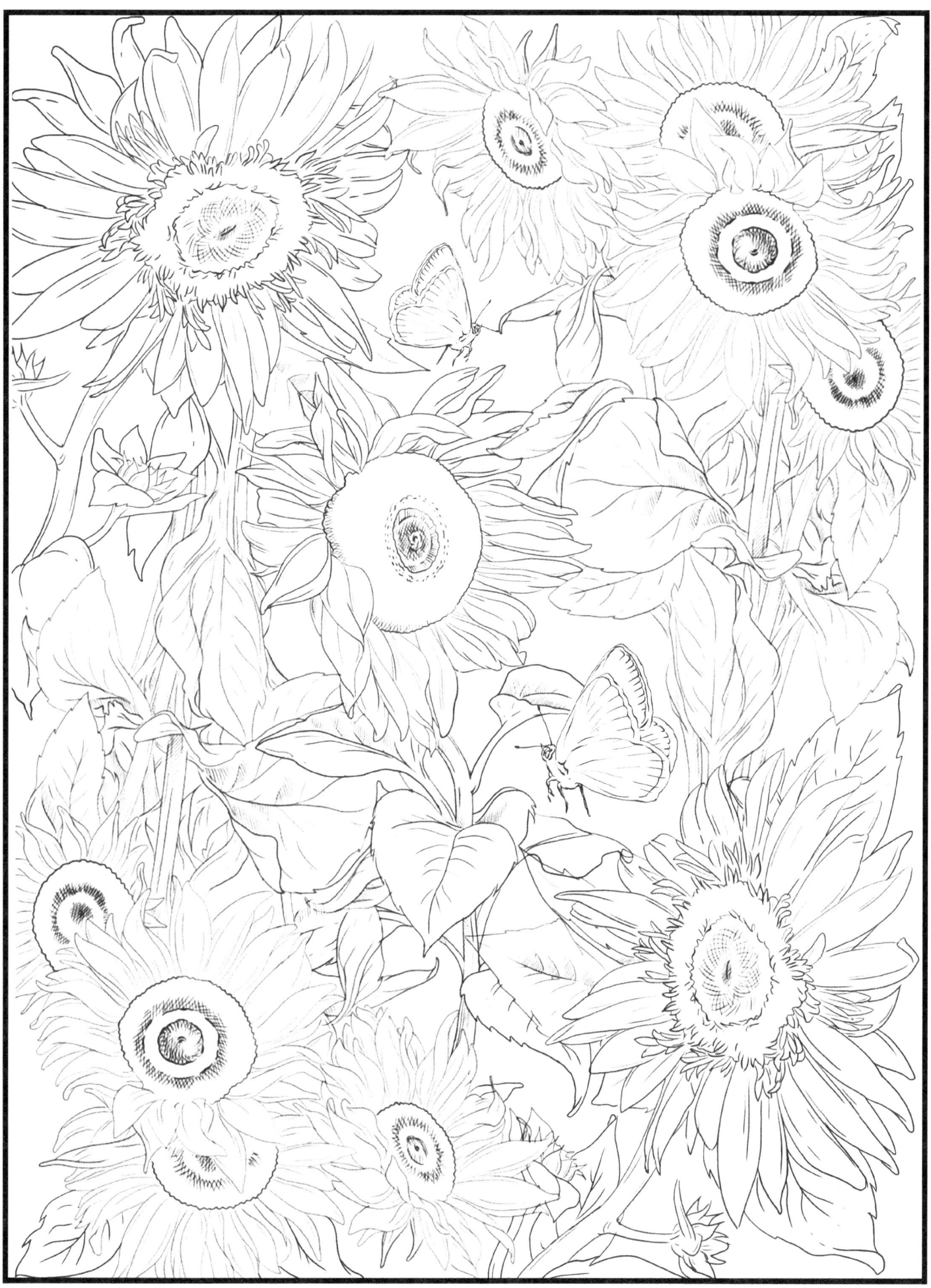

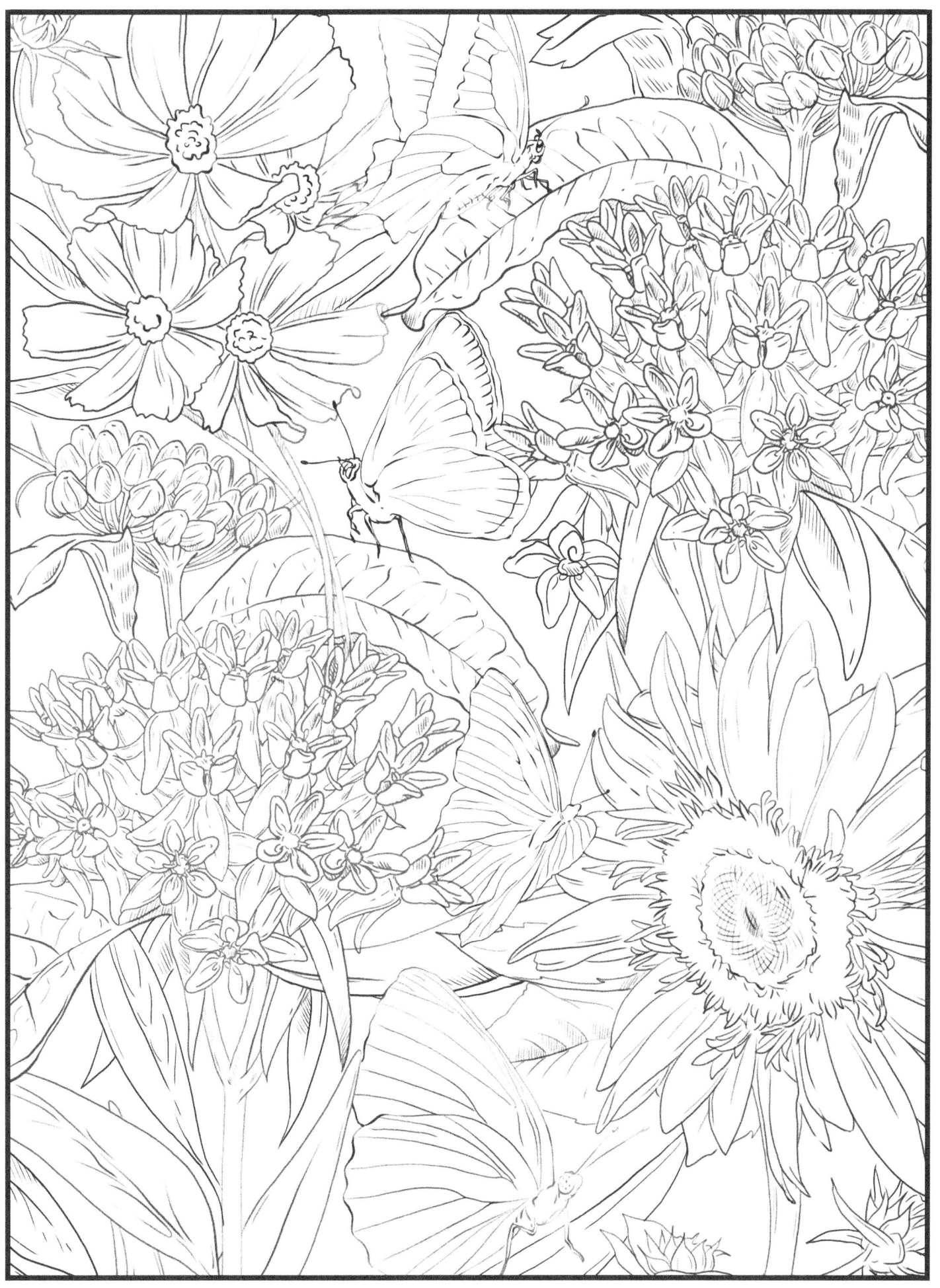

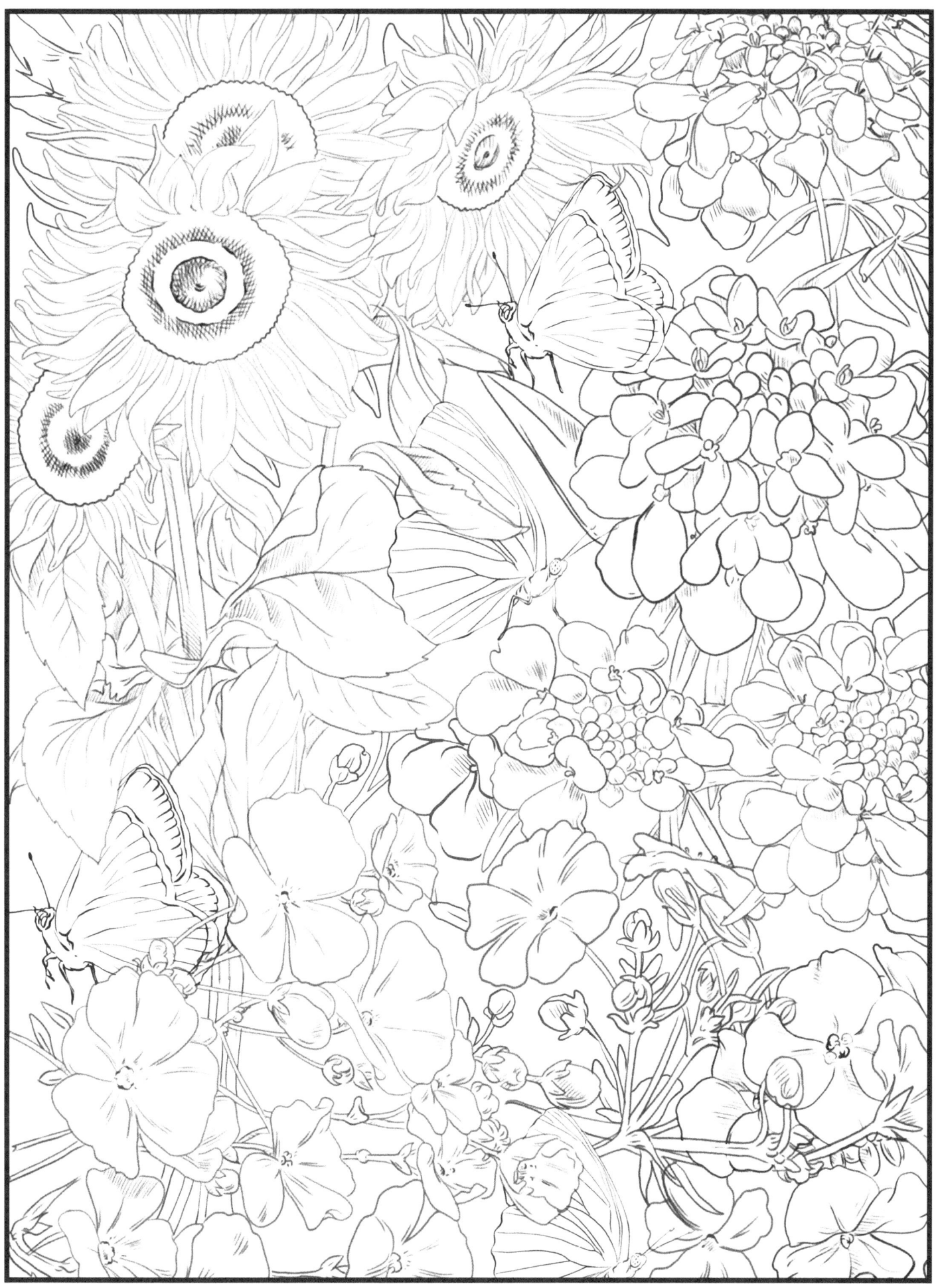

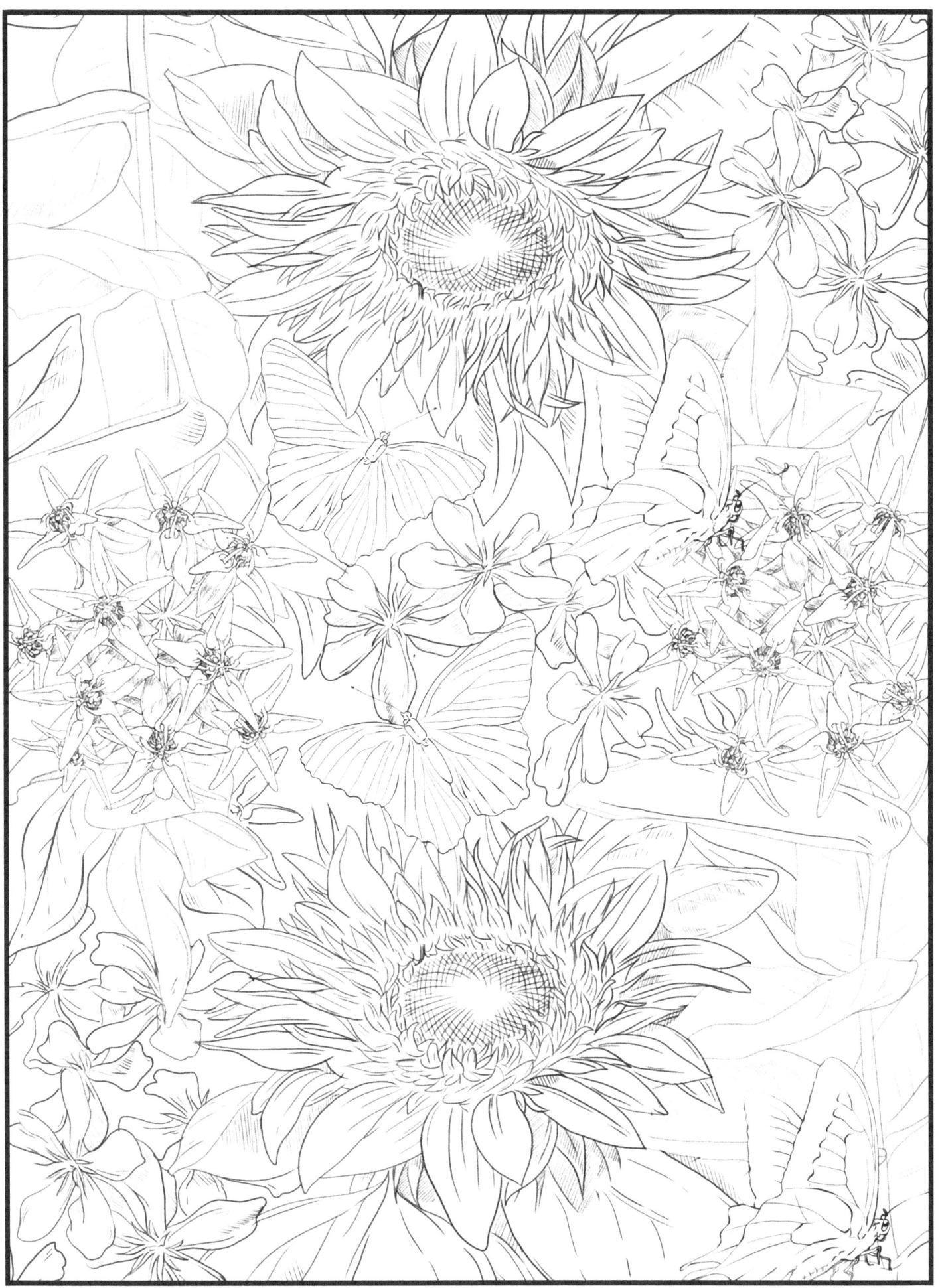

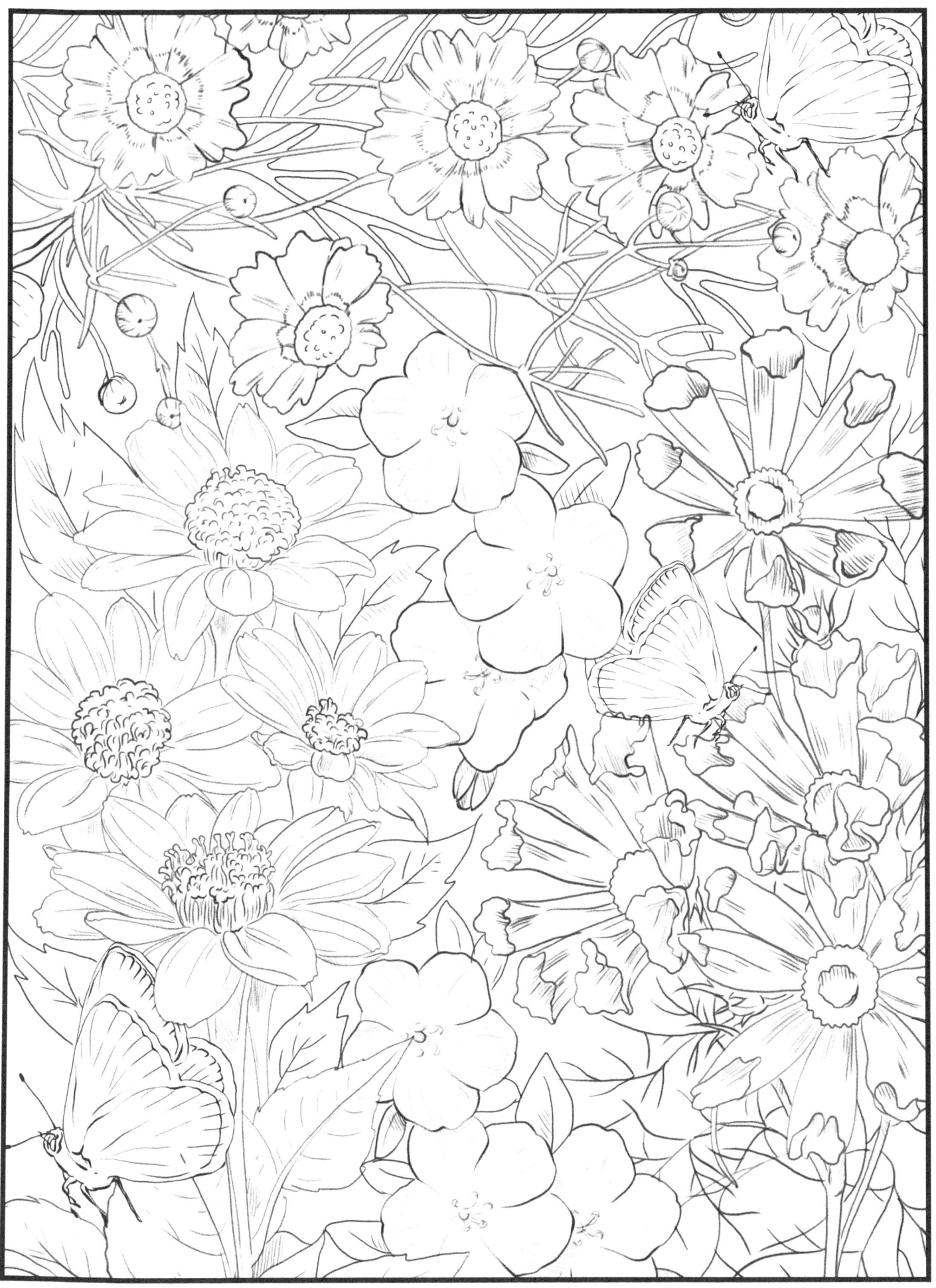

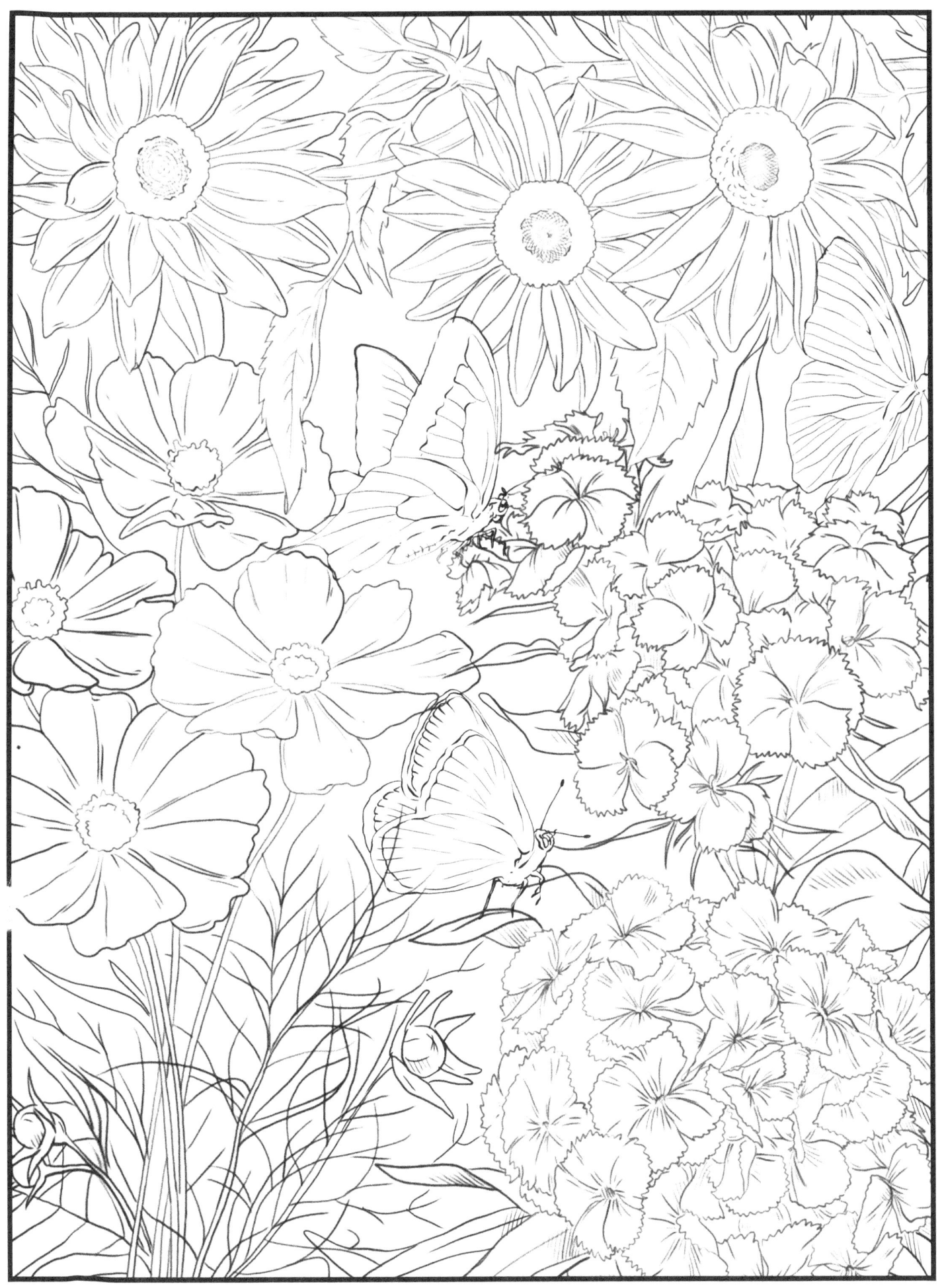

www.ingramcontent.com/pod-product-compliance
Lightning Source LLC
Chambersburg PA
CBHW080132240526
45468CB00009BA/2386